Copyright © 2017 by Anthony Teaford.
All rights reserved. No part of this document may be reproduced or transmitted in any form or by any means, electronic, mechanical, photocopying, recording, or otherwise, without prior written permission of Anthony Teaford.

Printed in the United States Of America

ISBN#: 978-1-365-74033-6

Contact@ ateaford@gmail.com

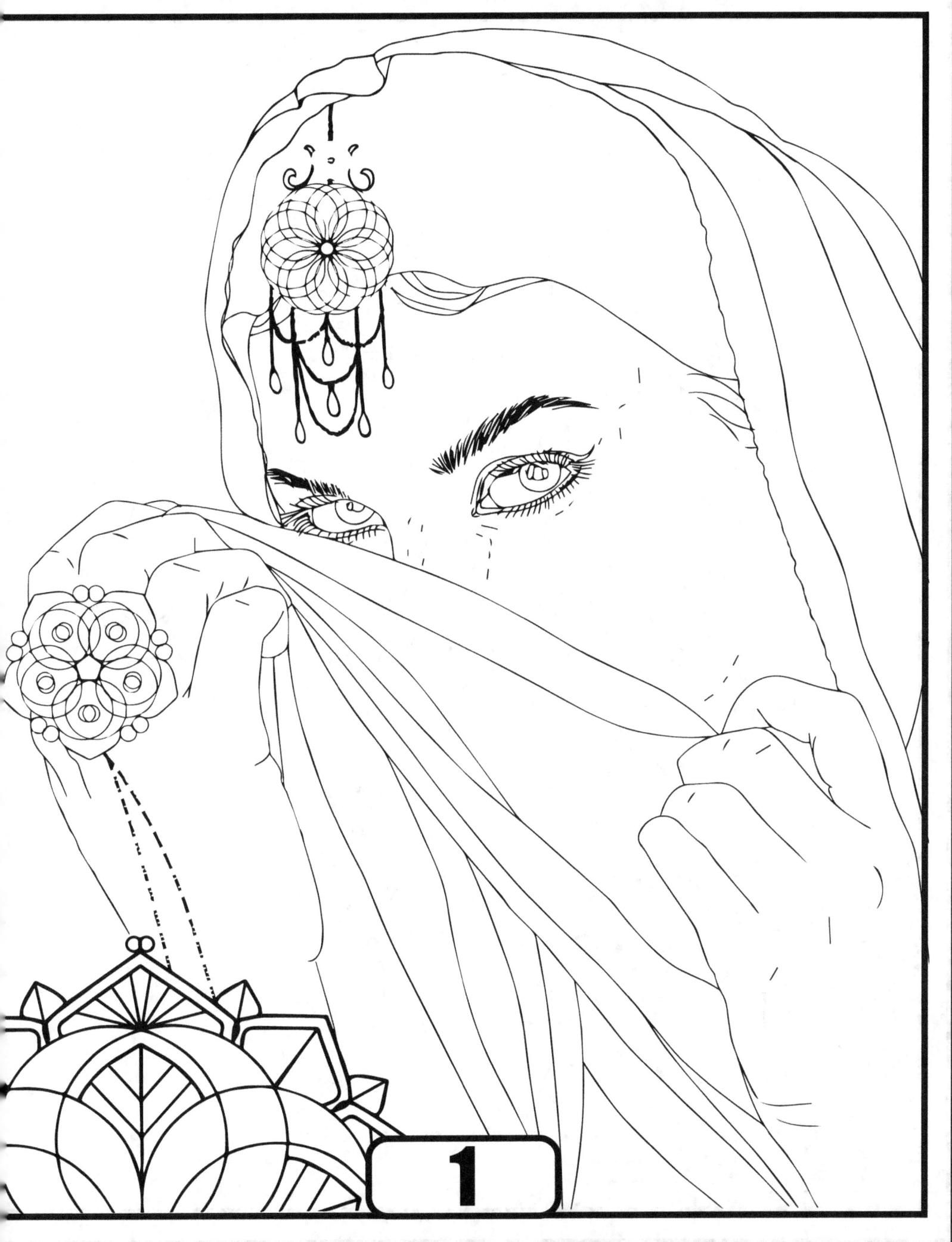

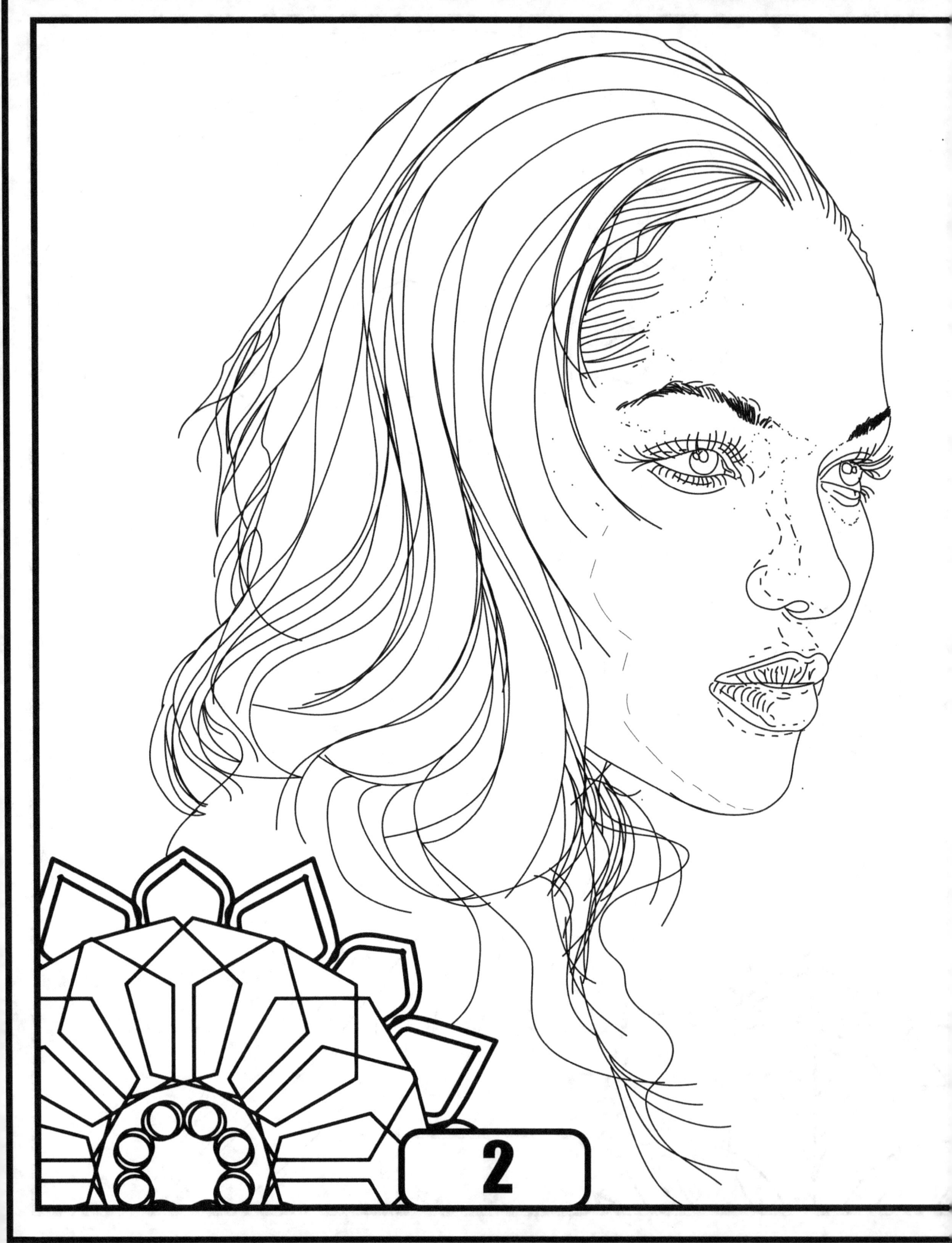

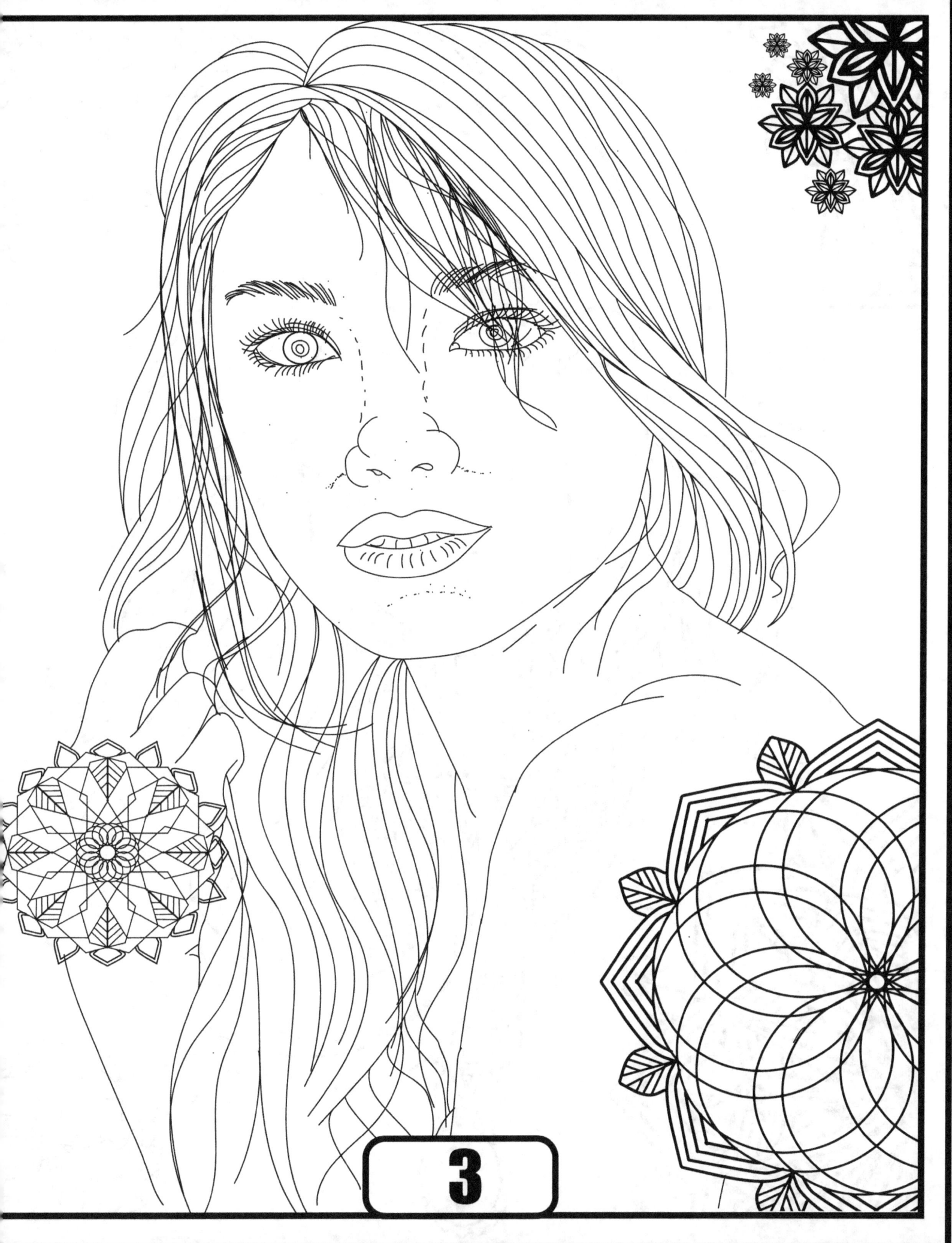

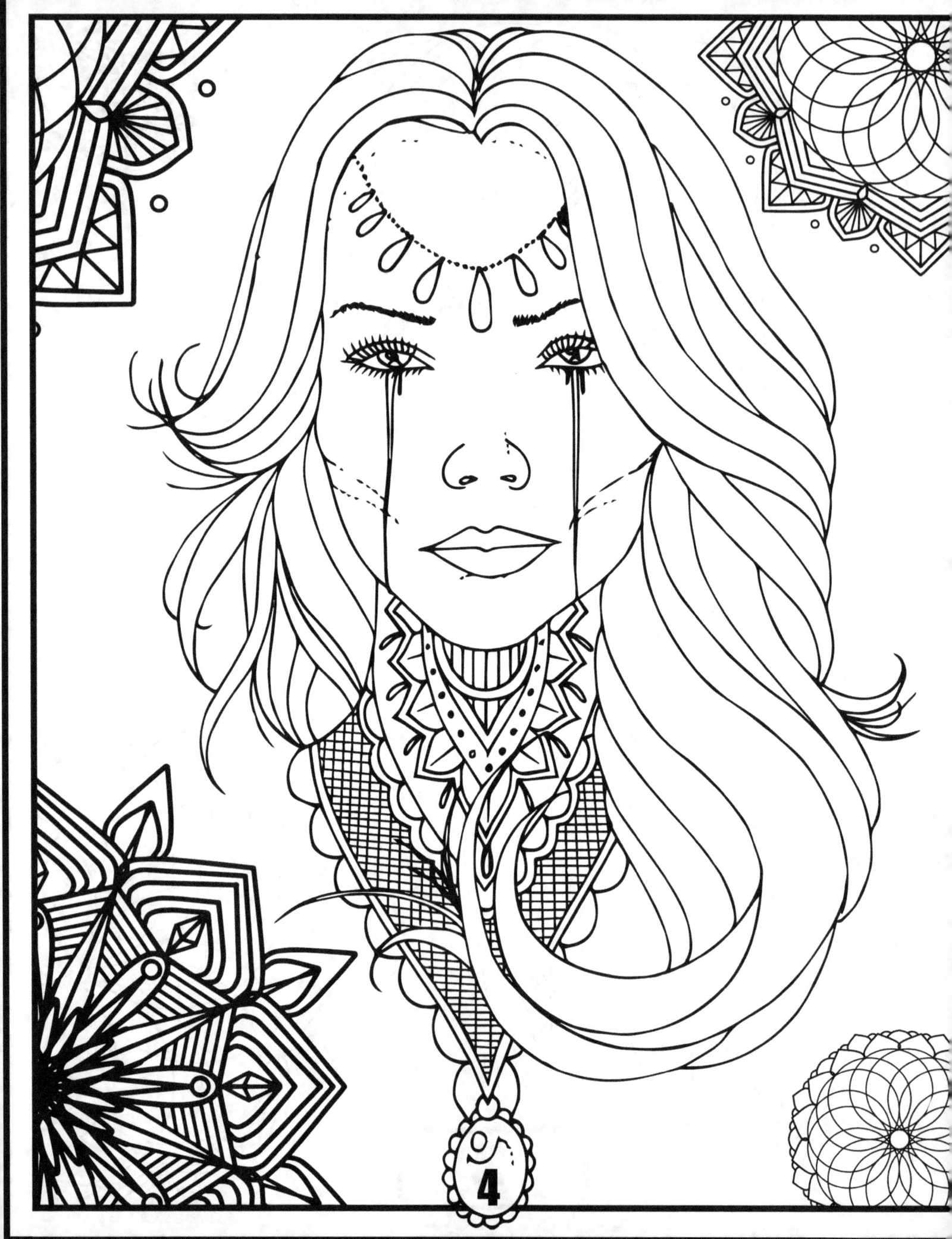

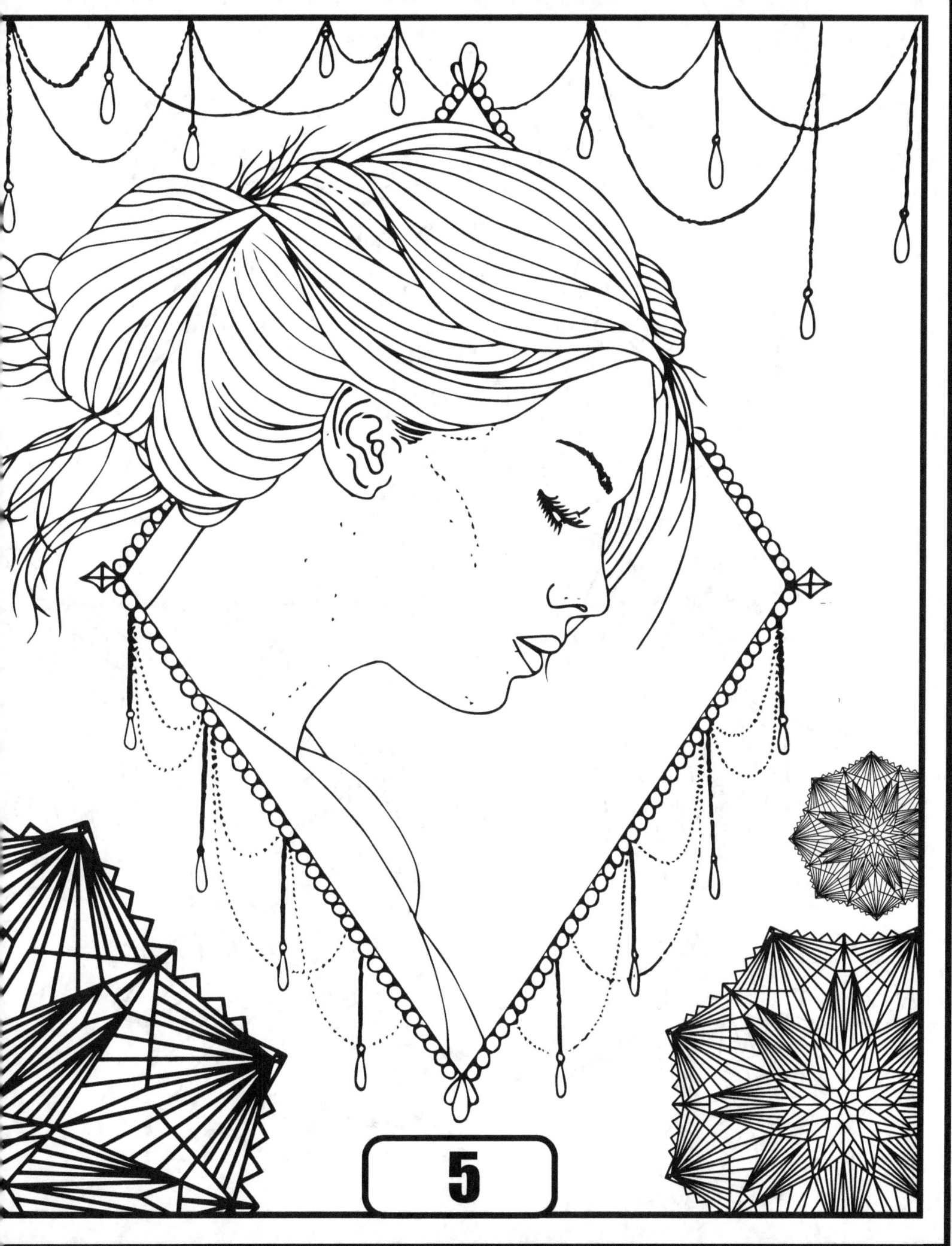

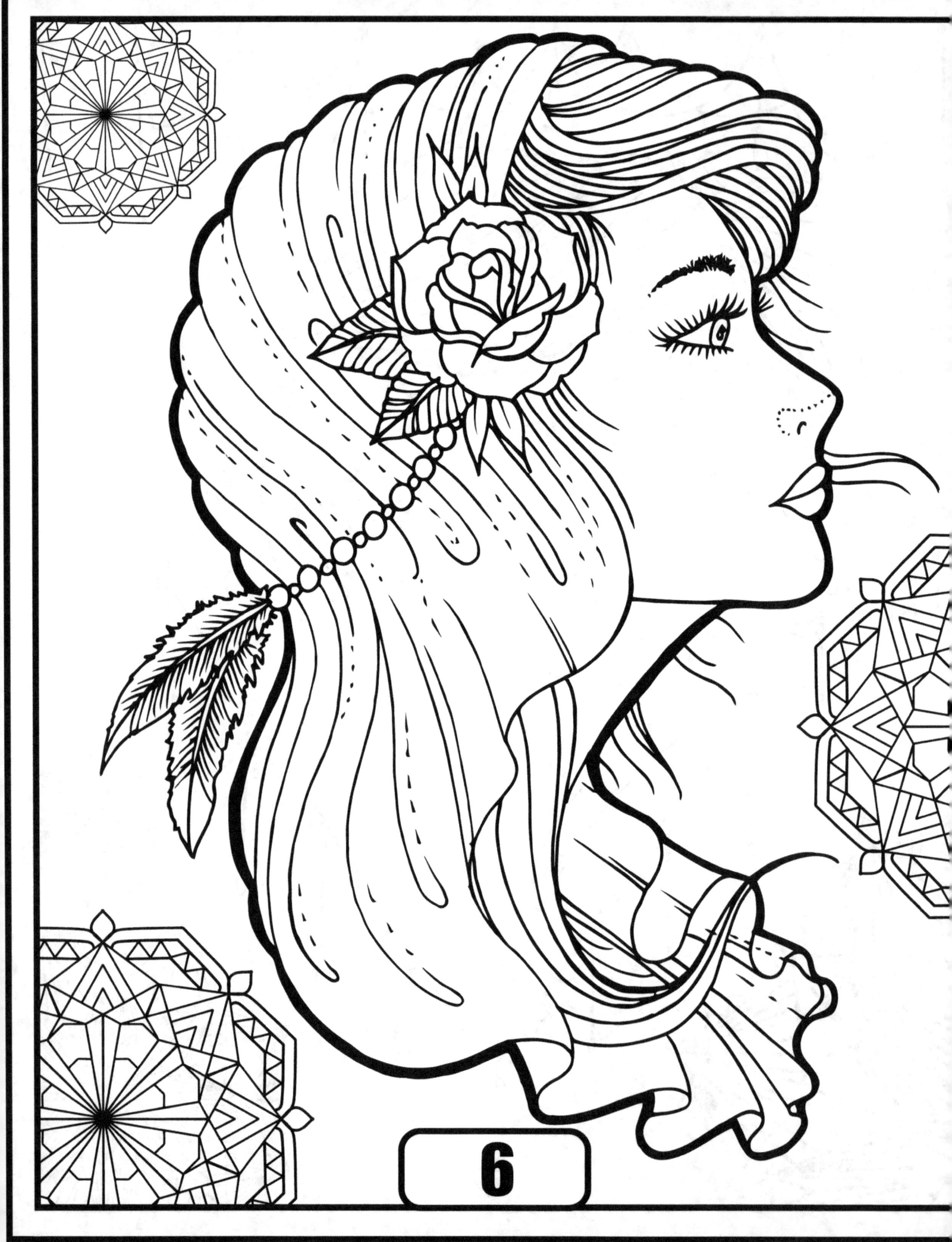

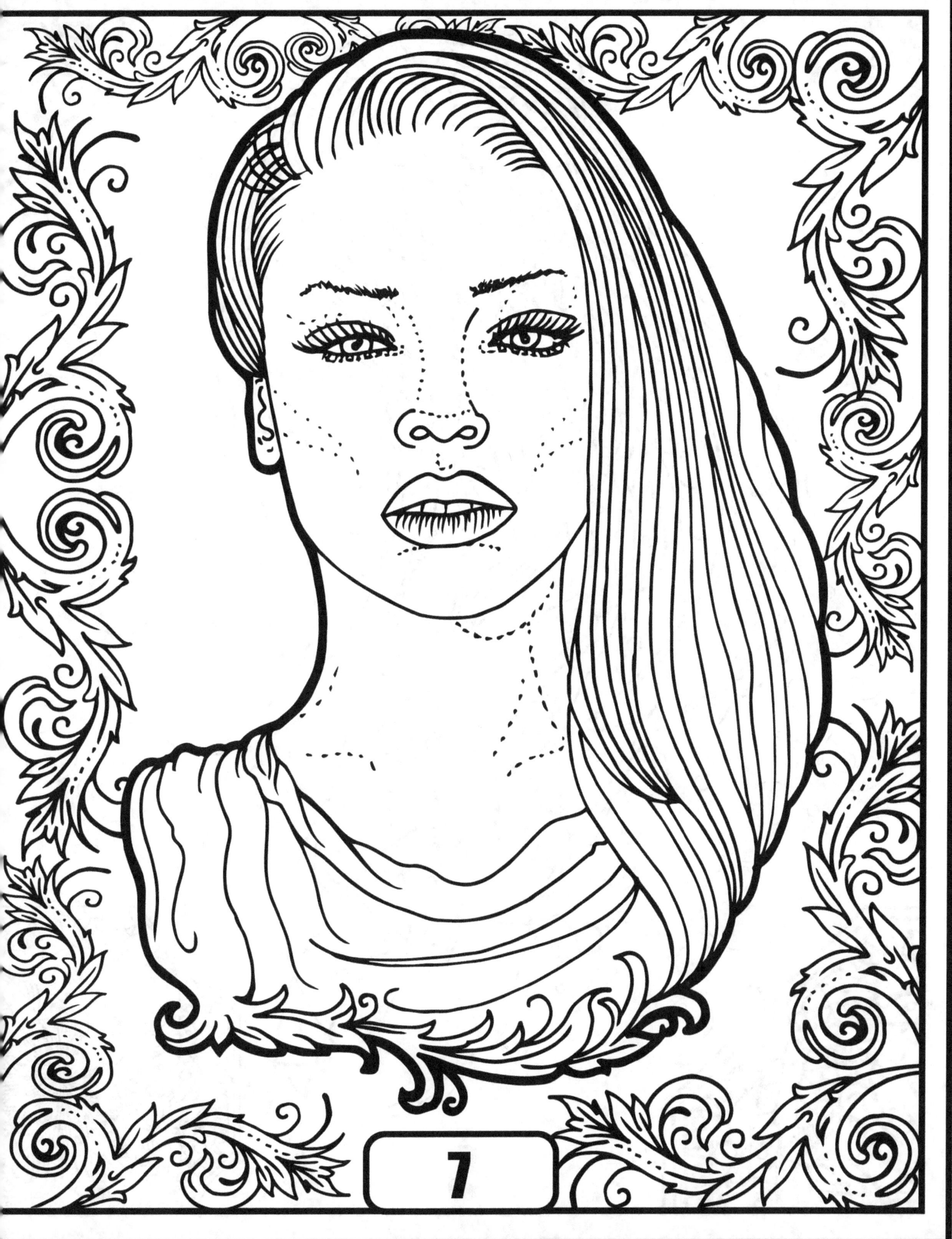

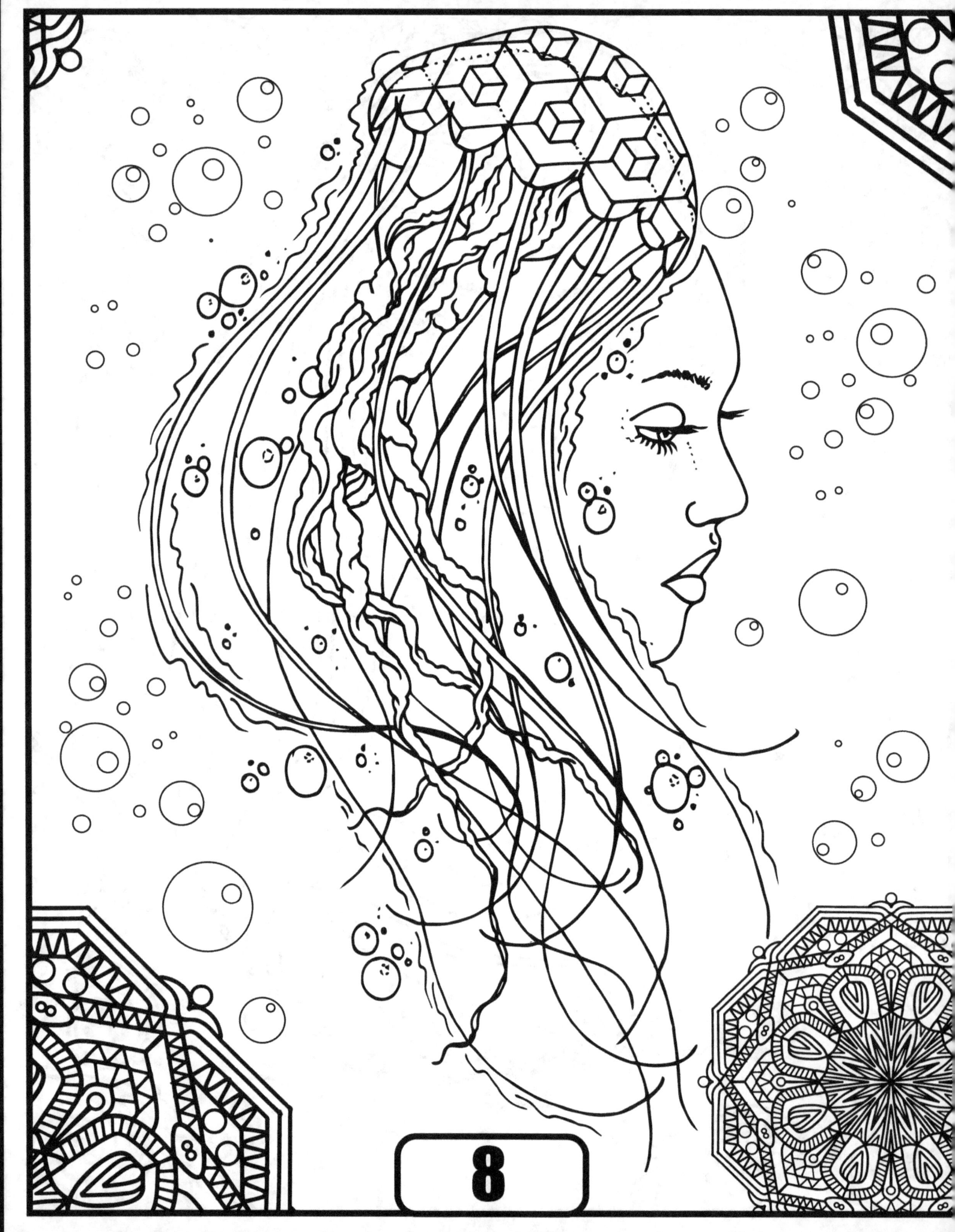

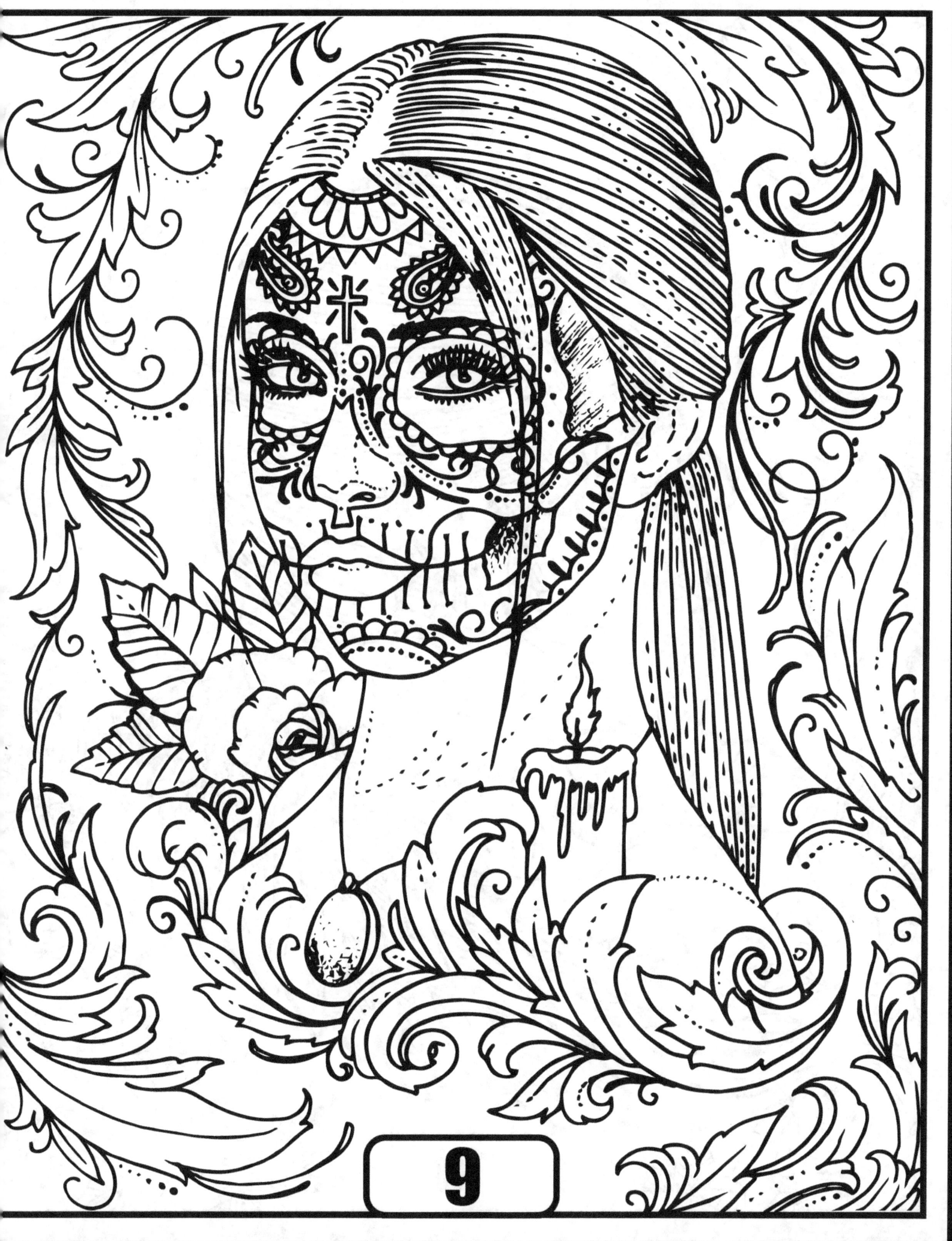

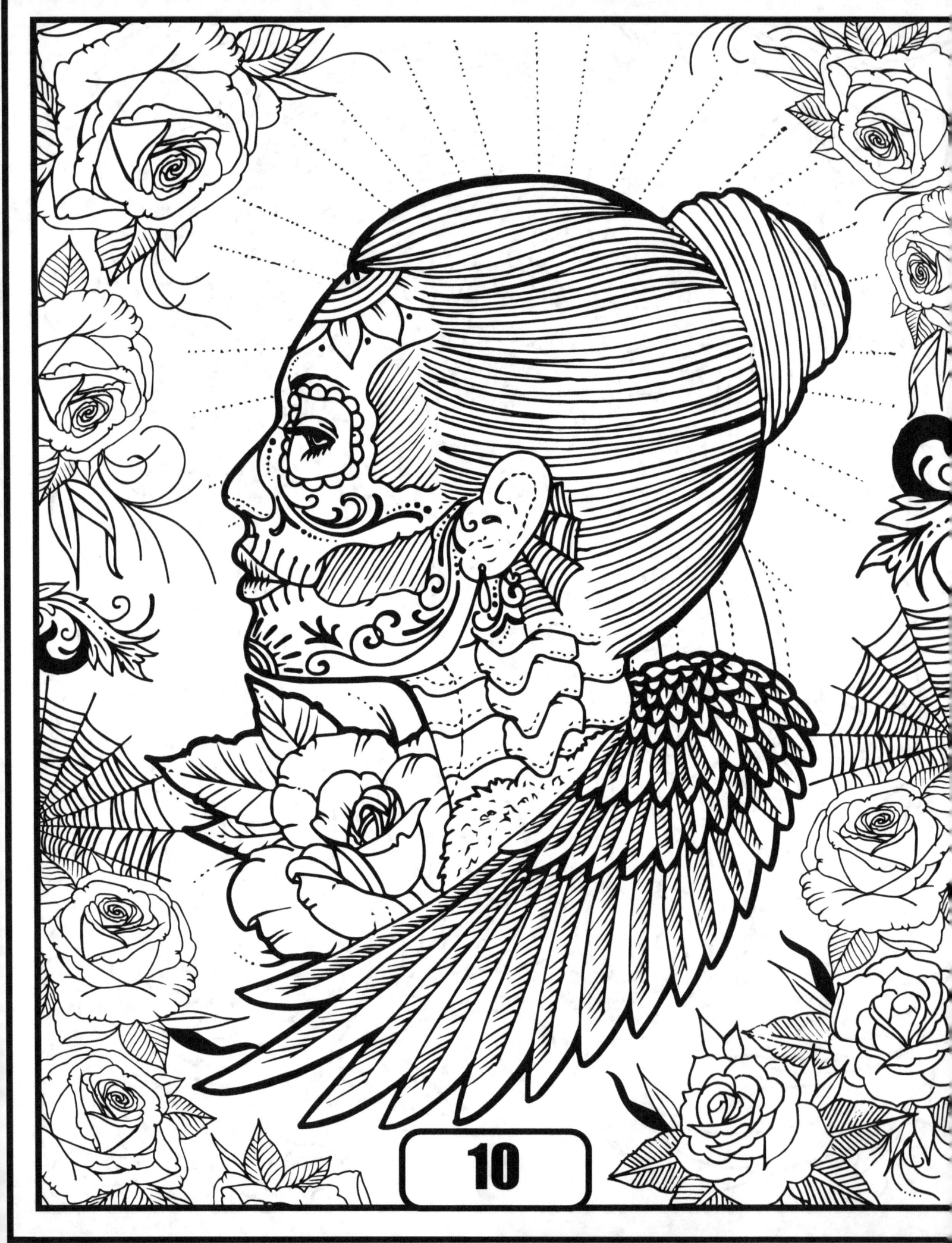

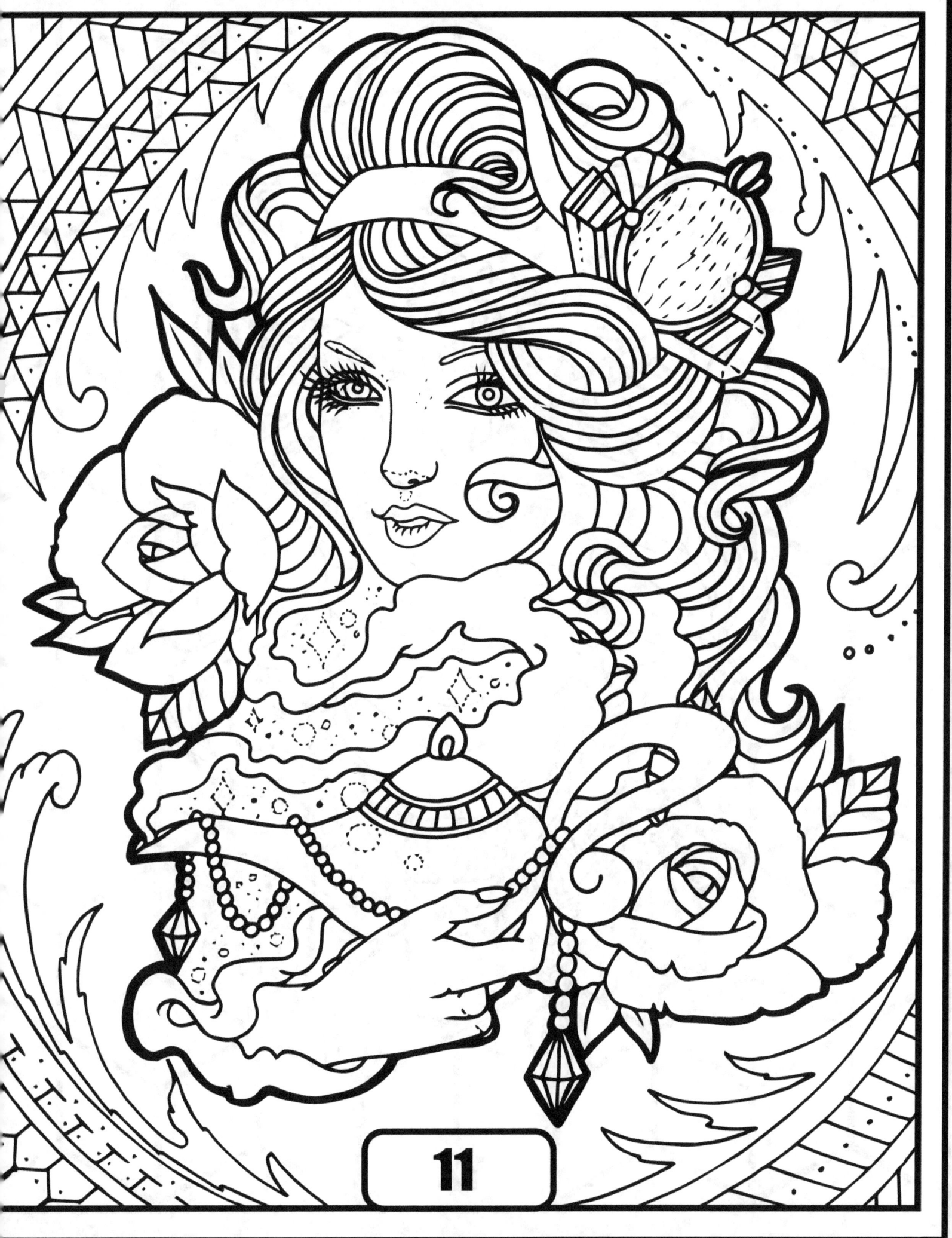

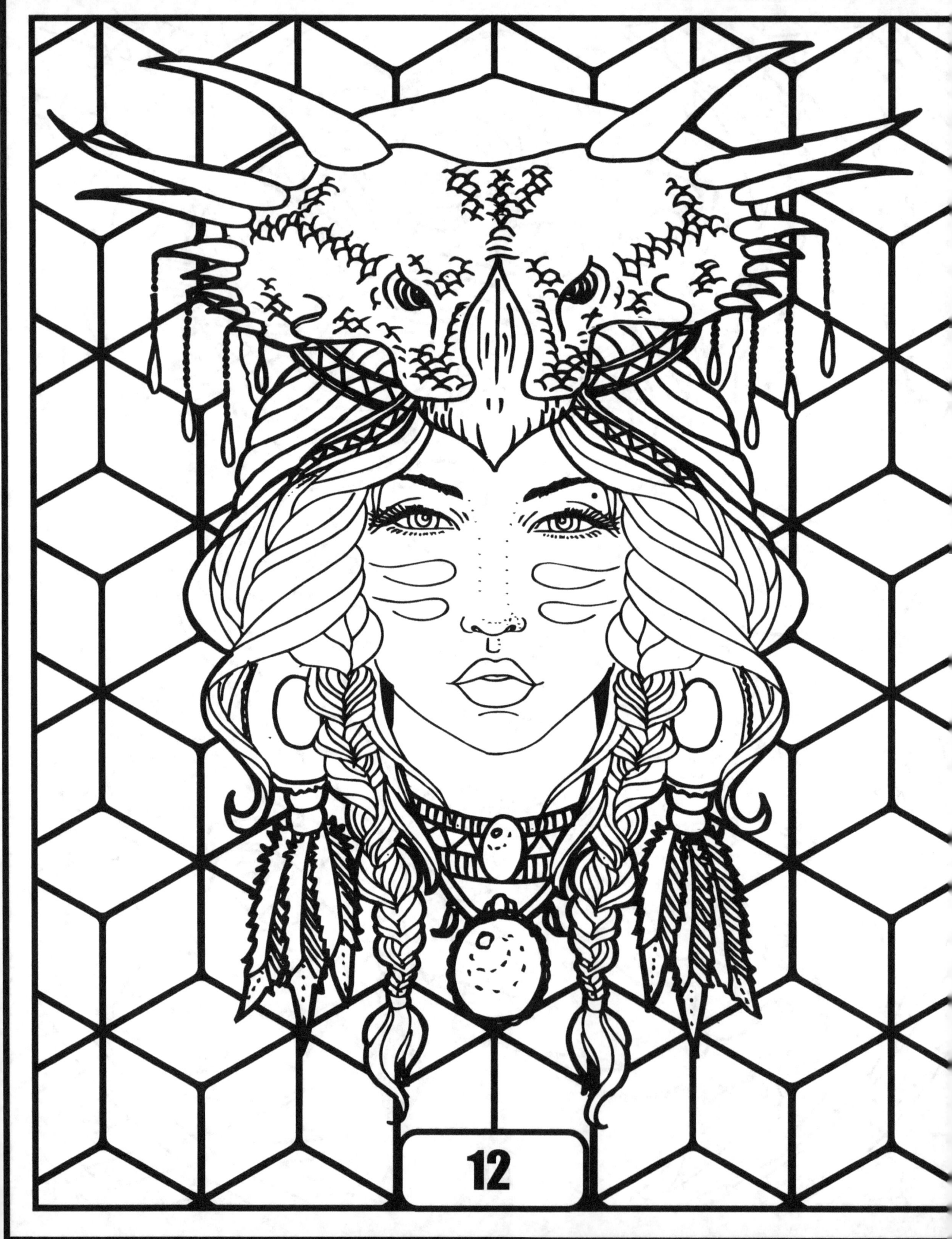

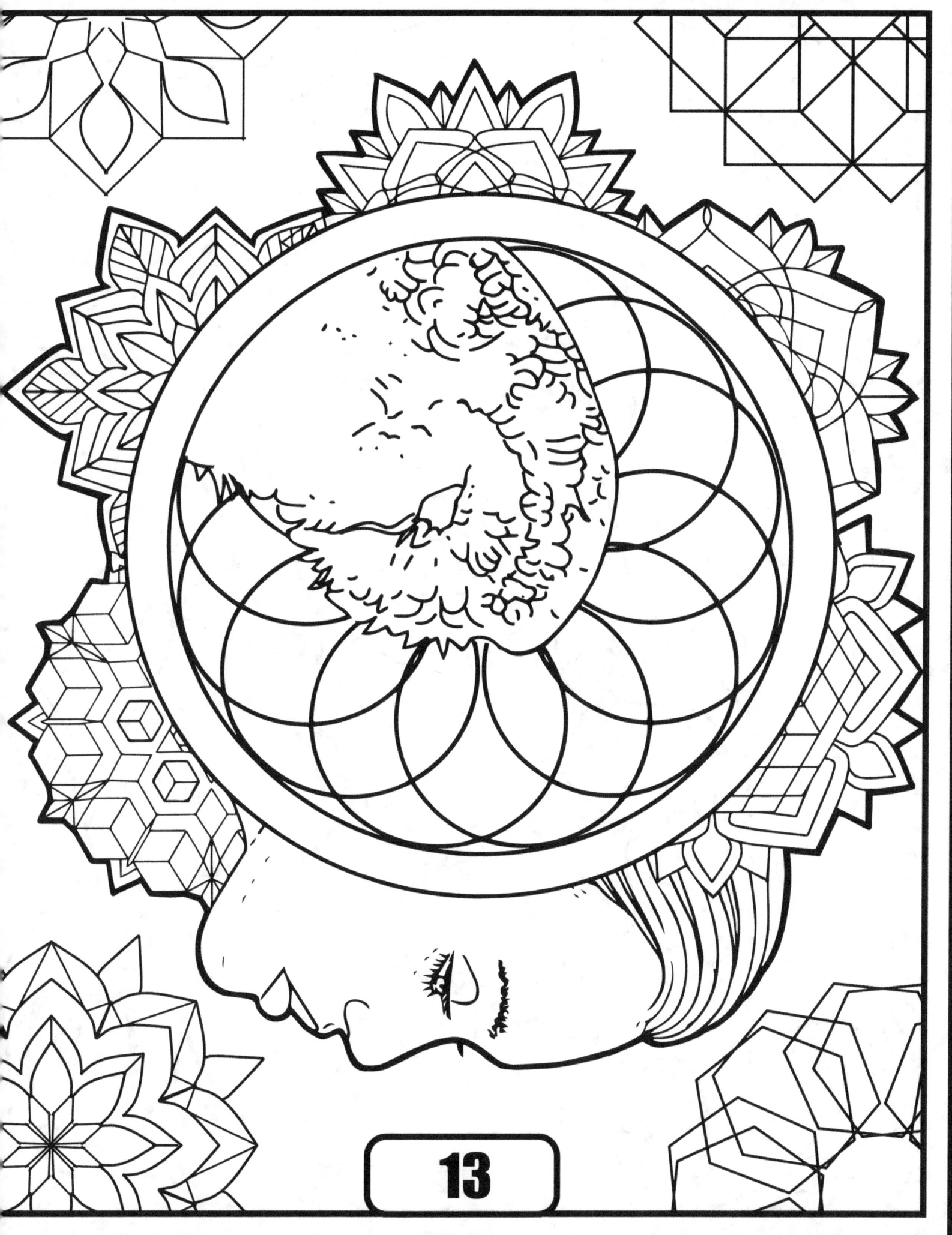

13

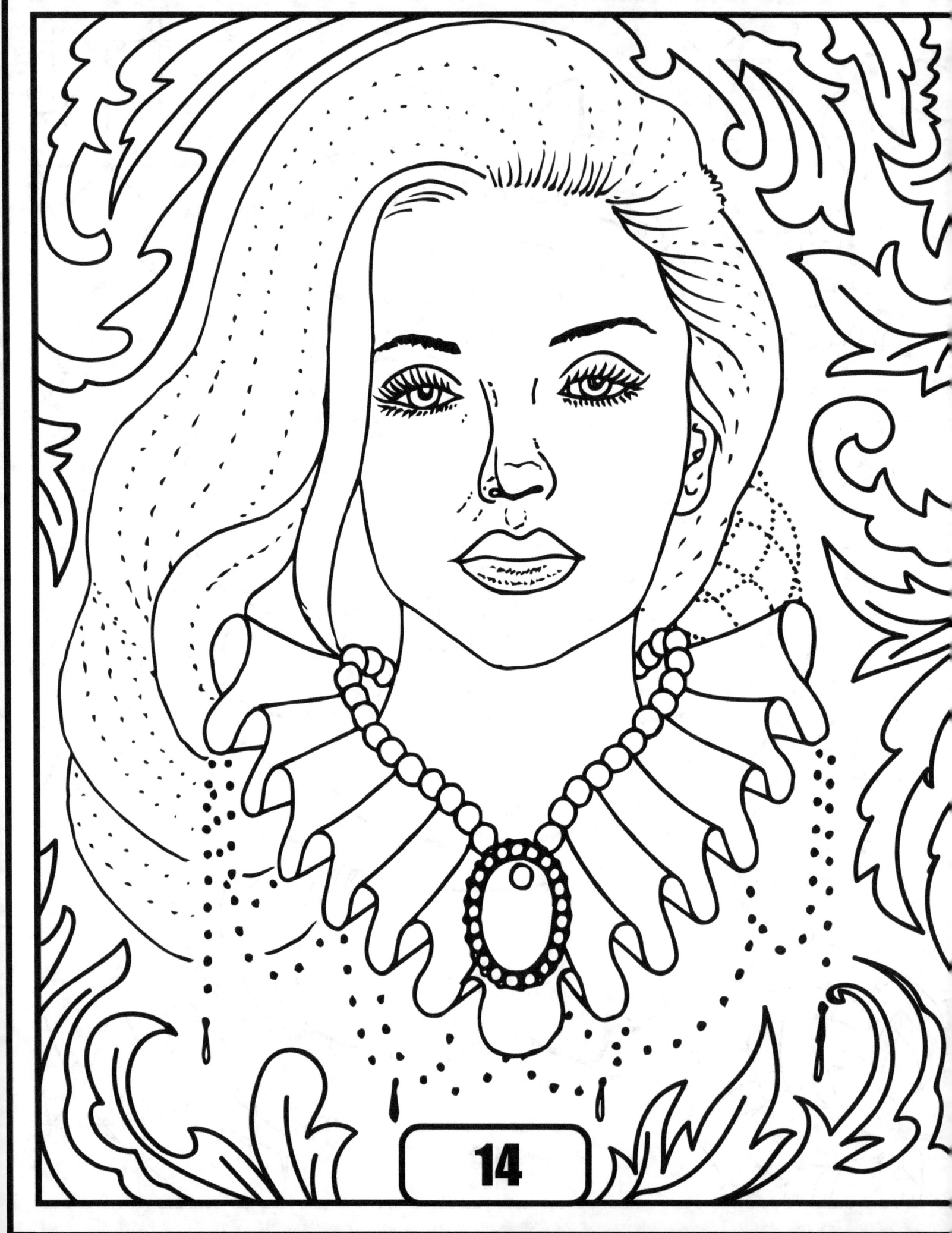

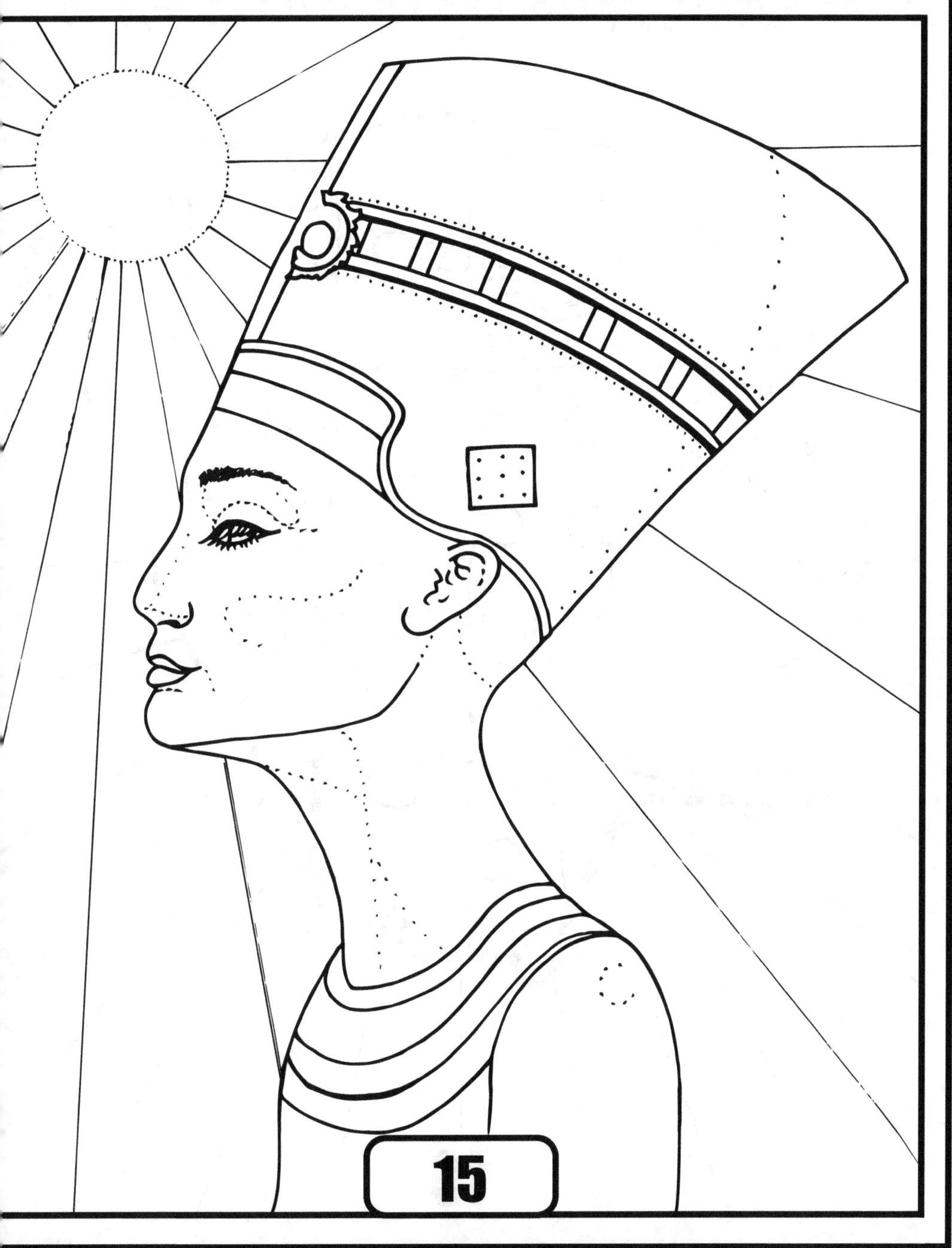

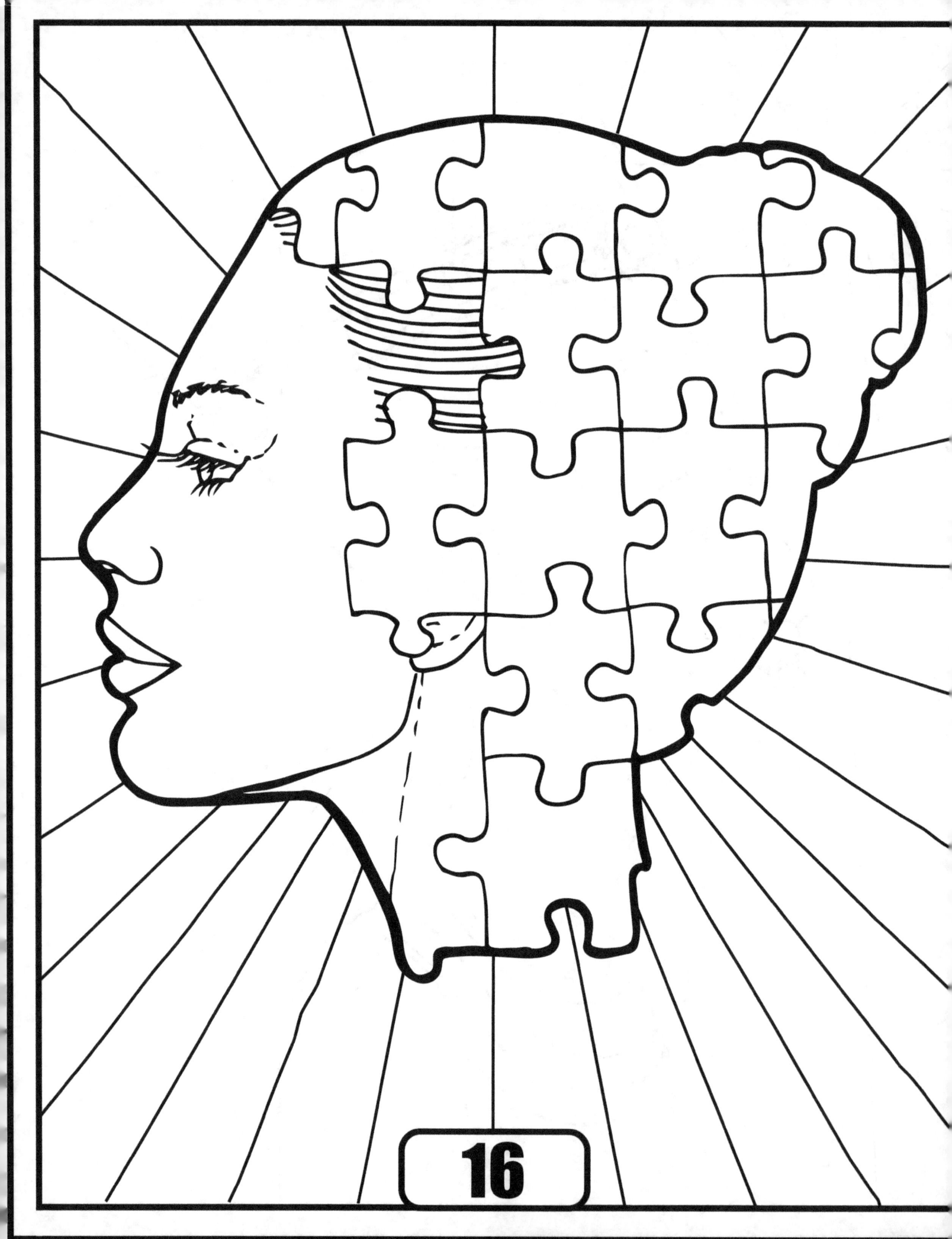

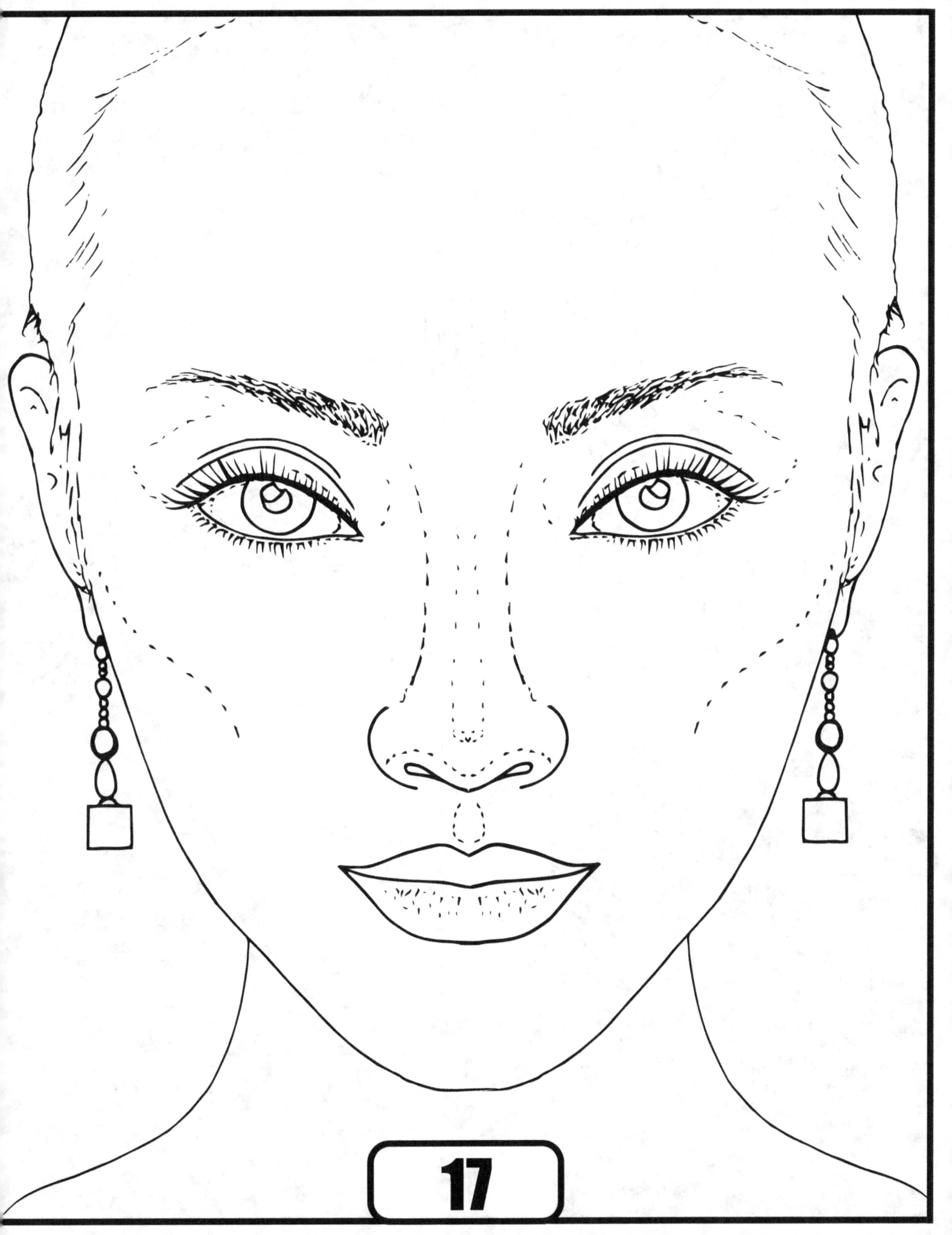

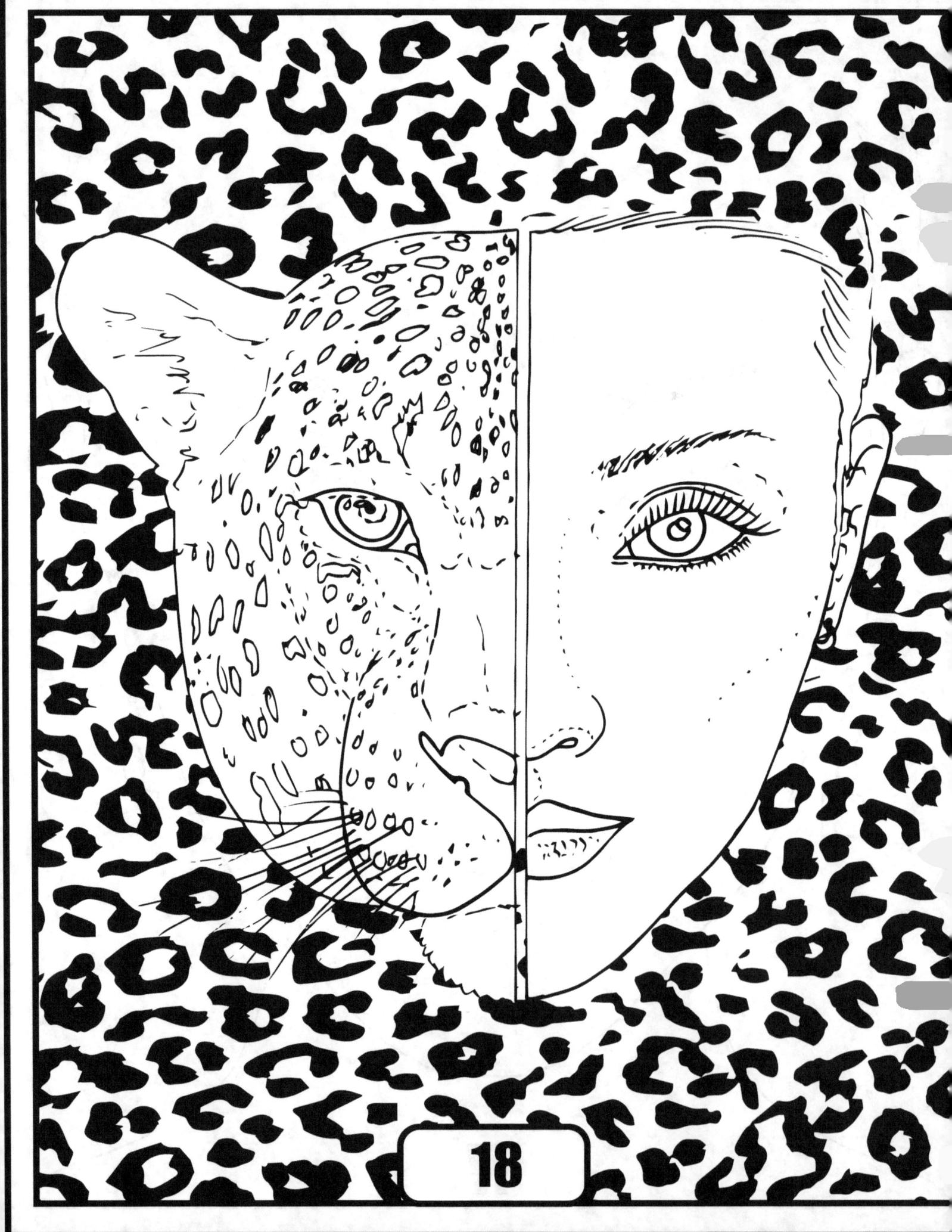

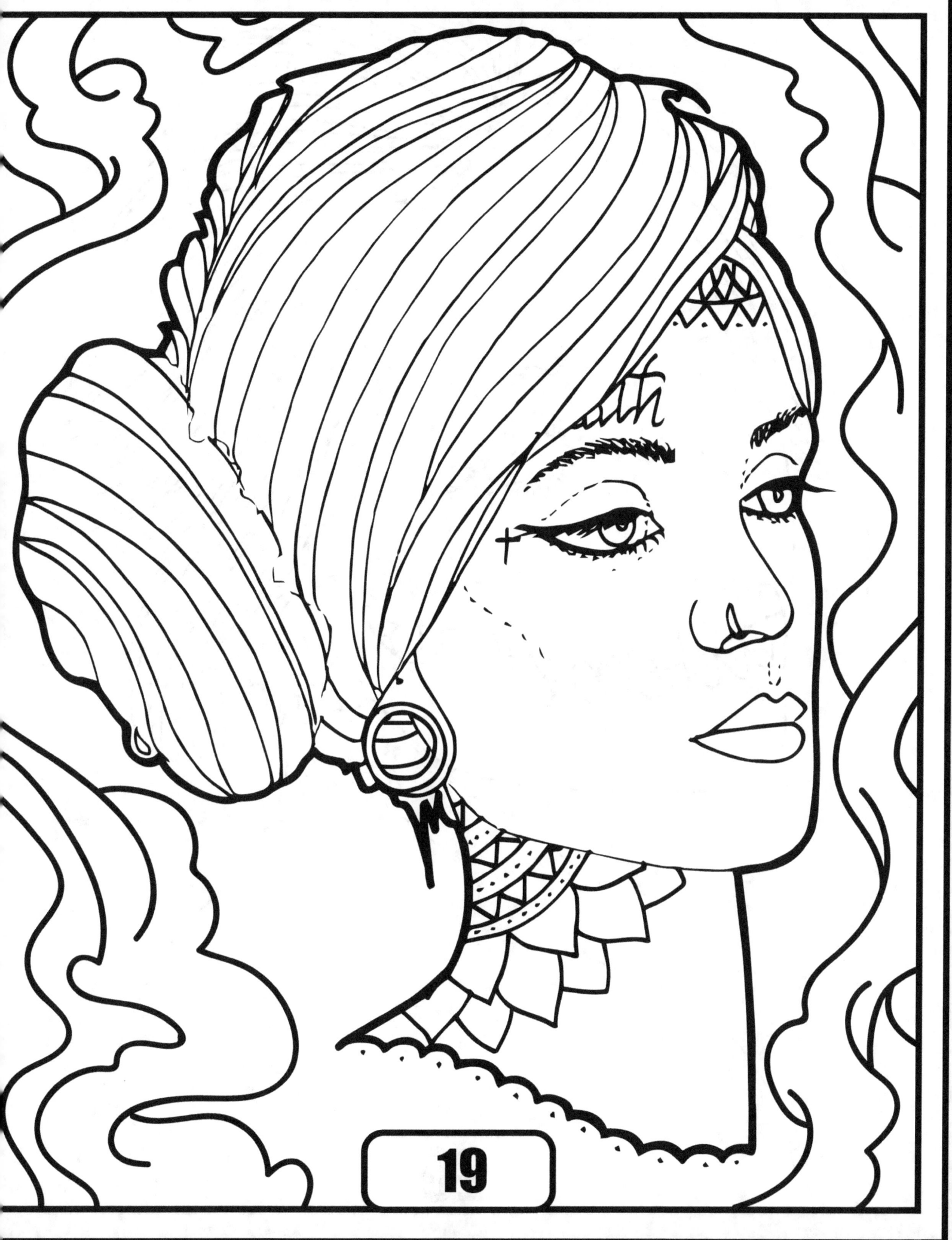

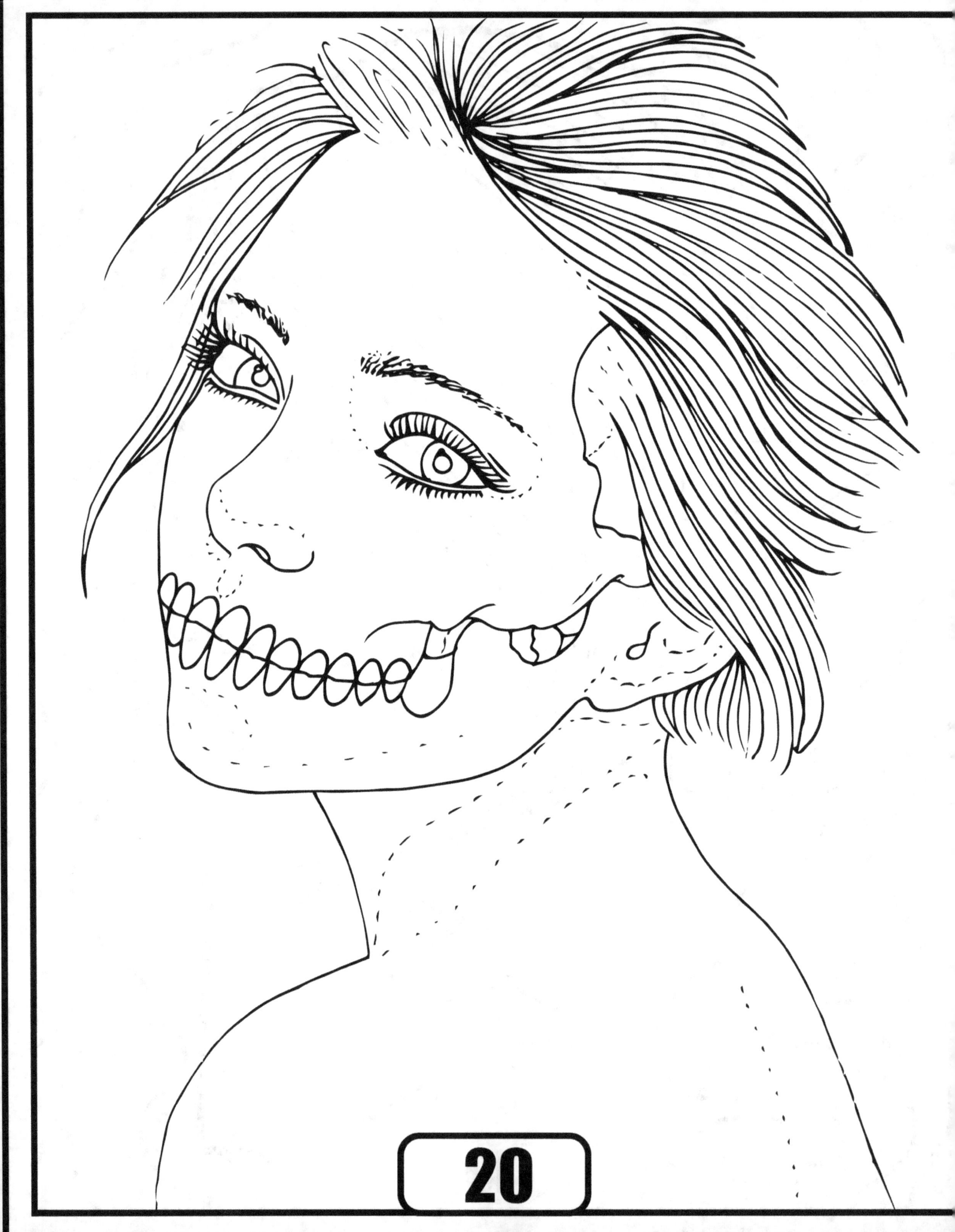

20

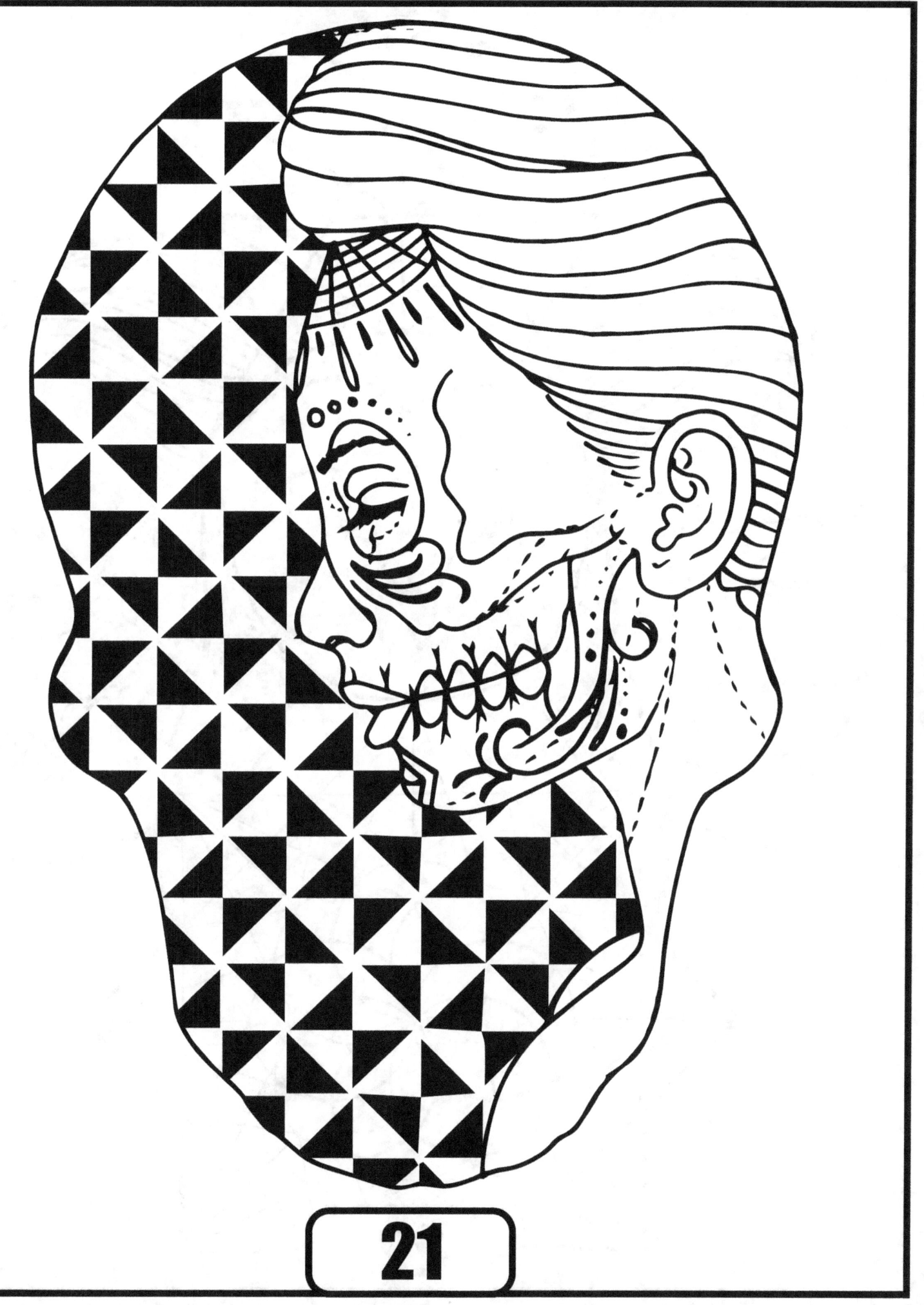

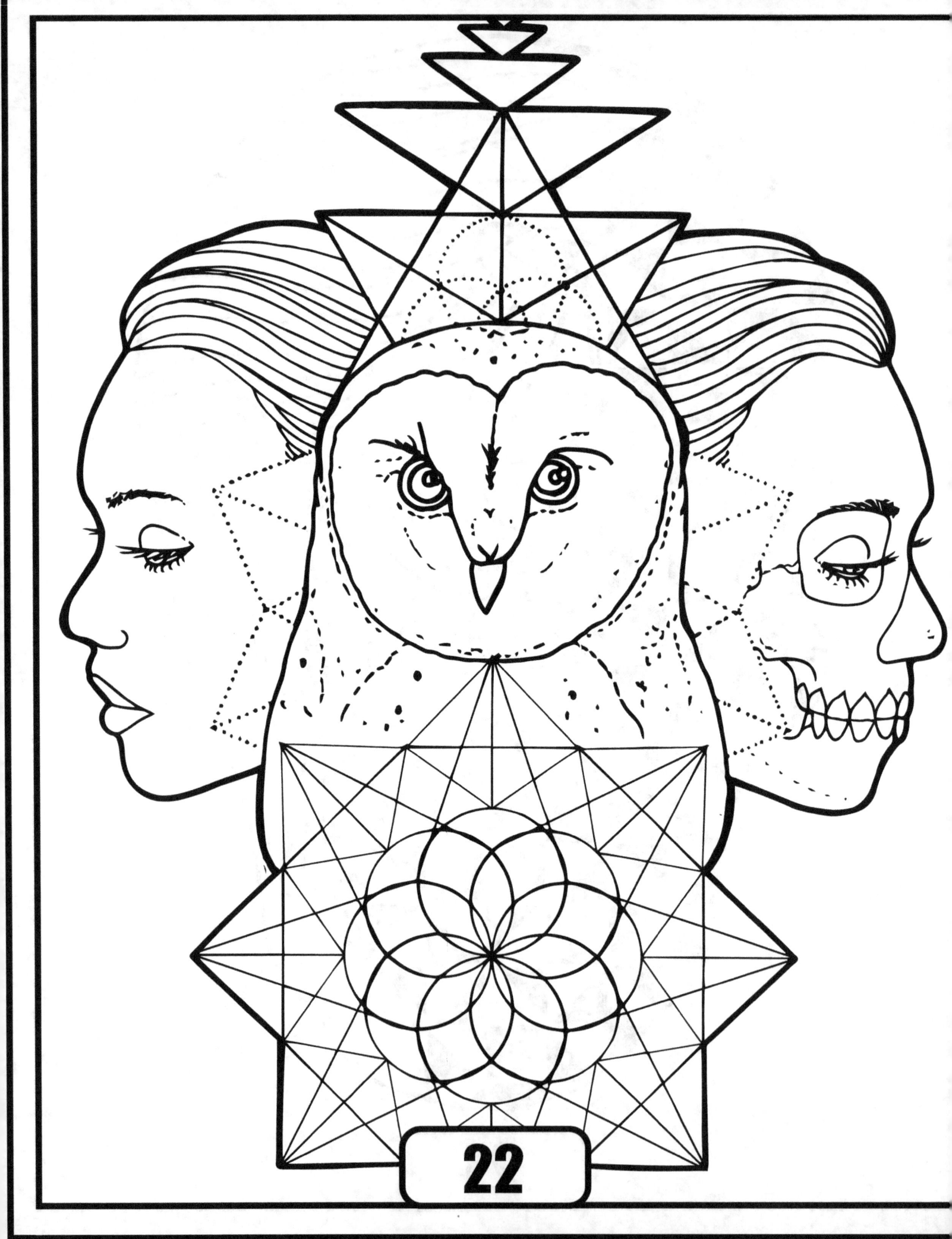

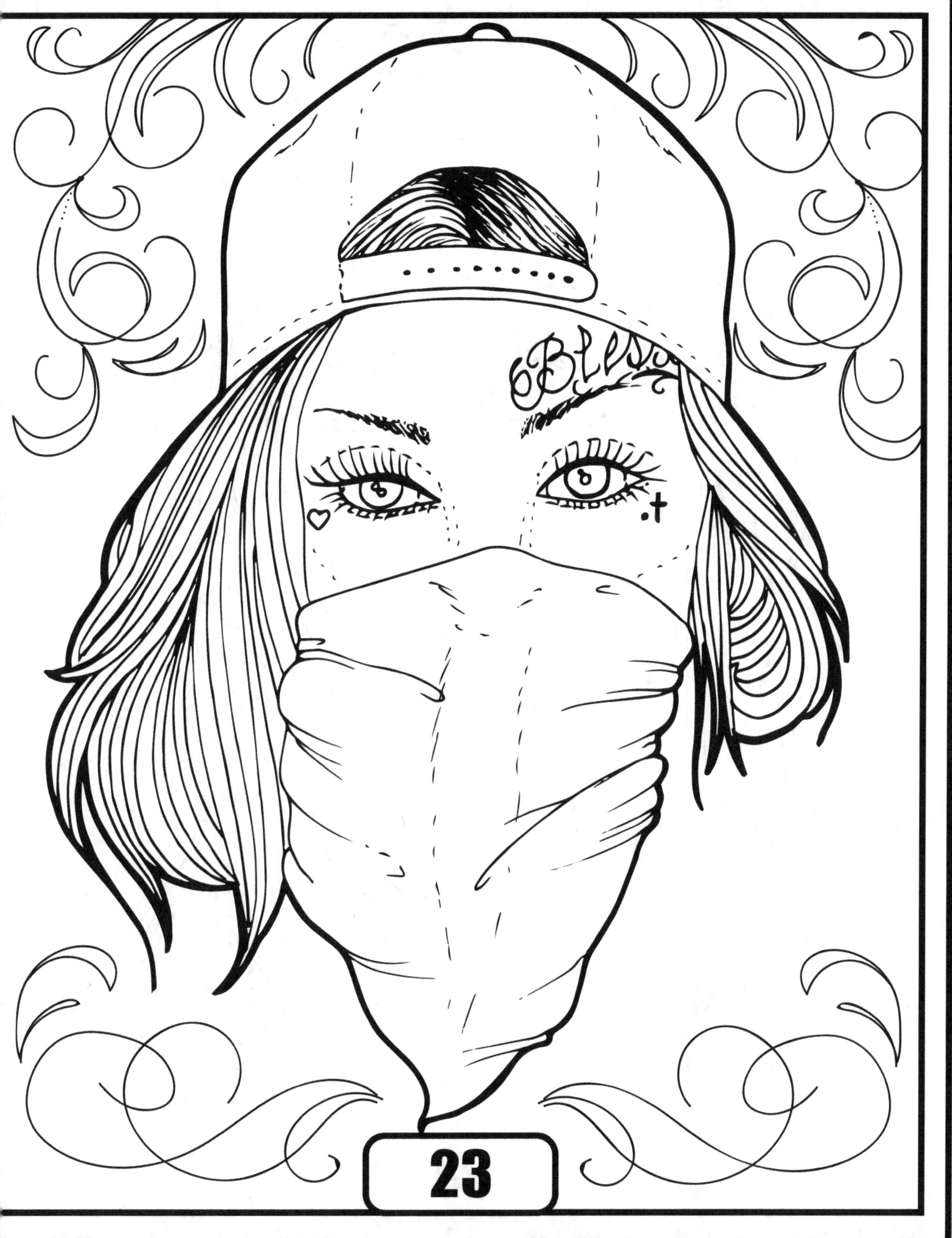

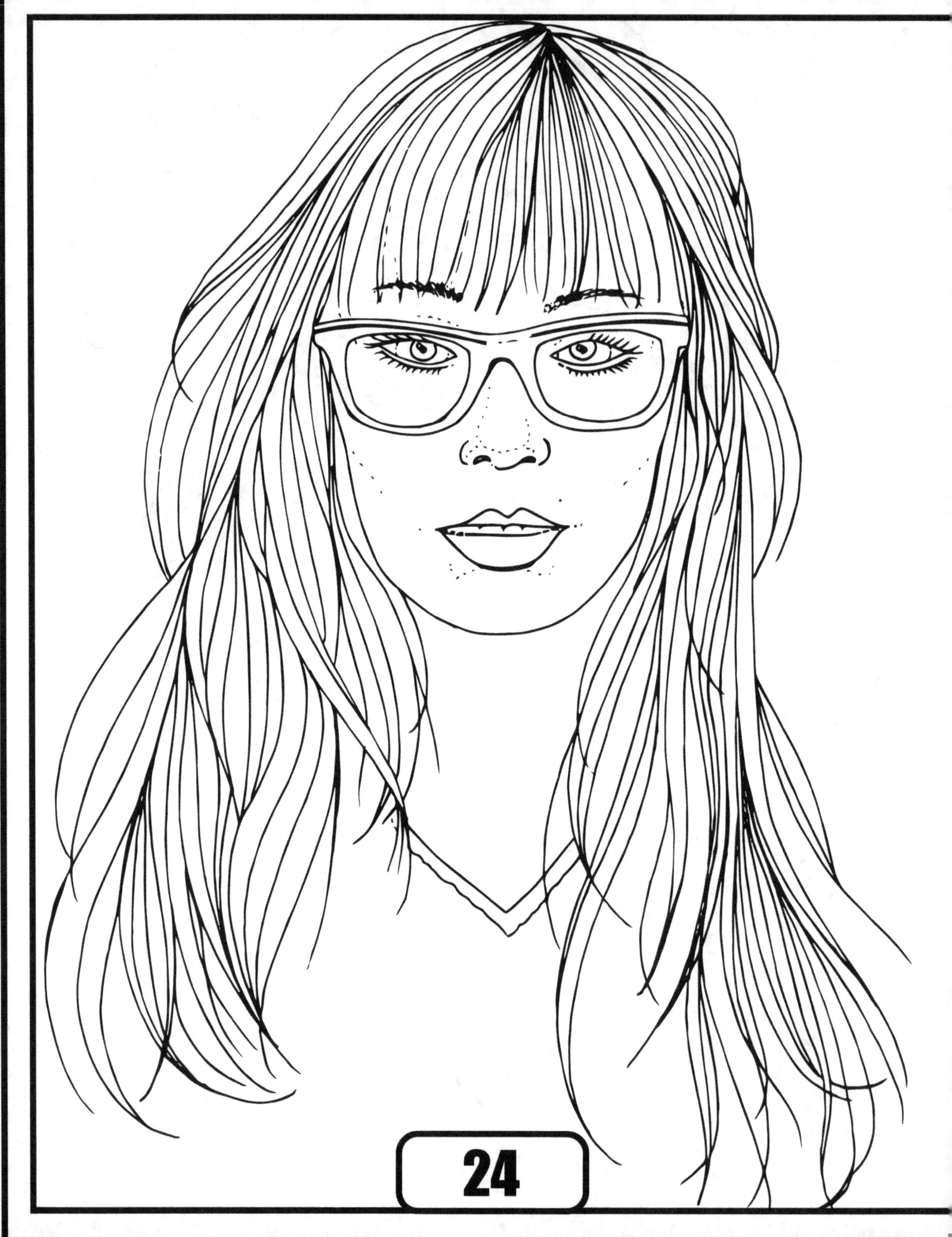

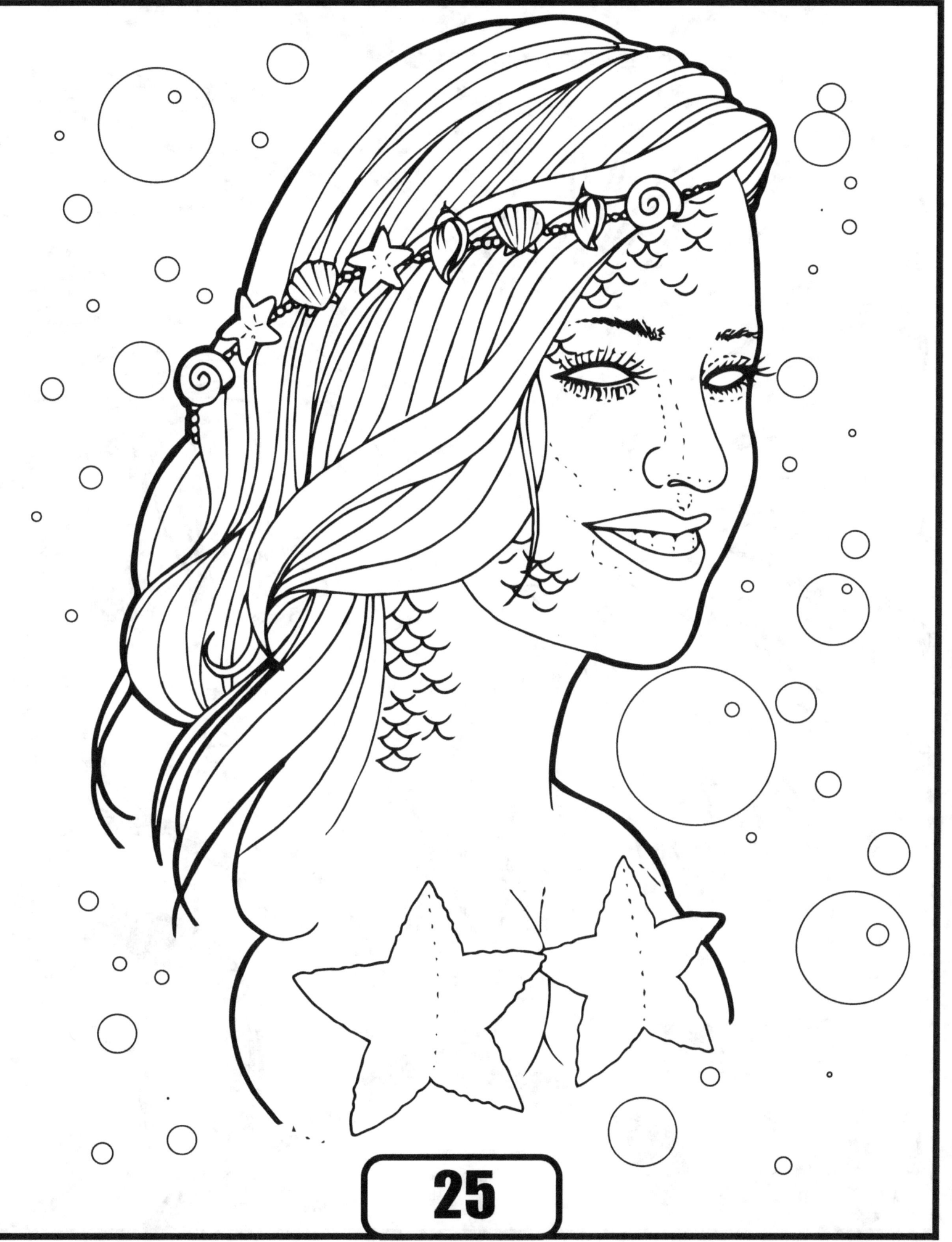

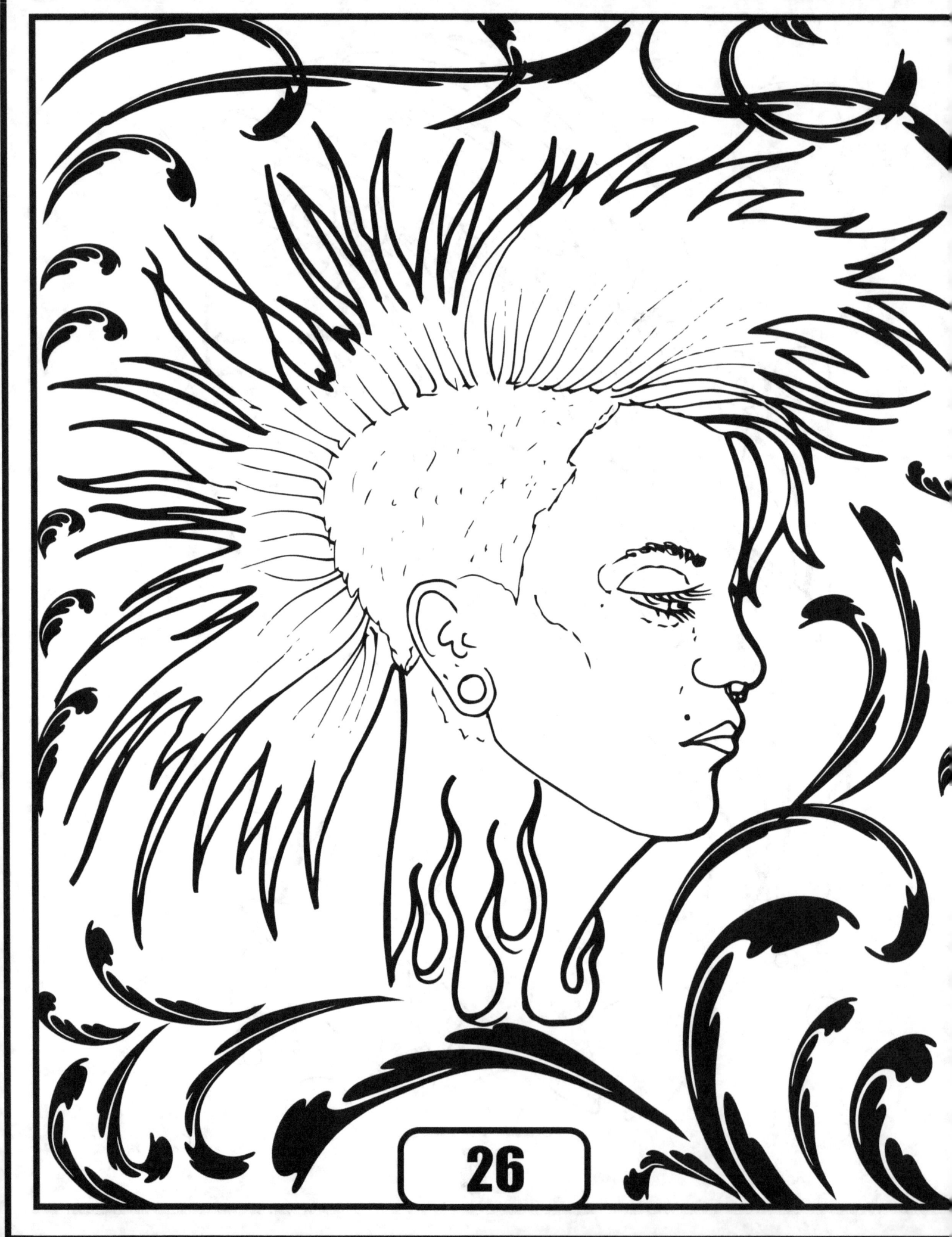

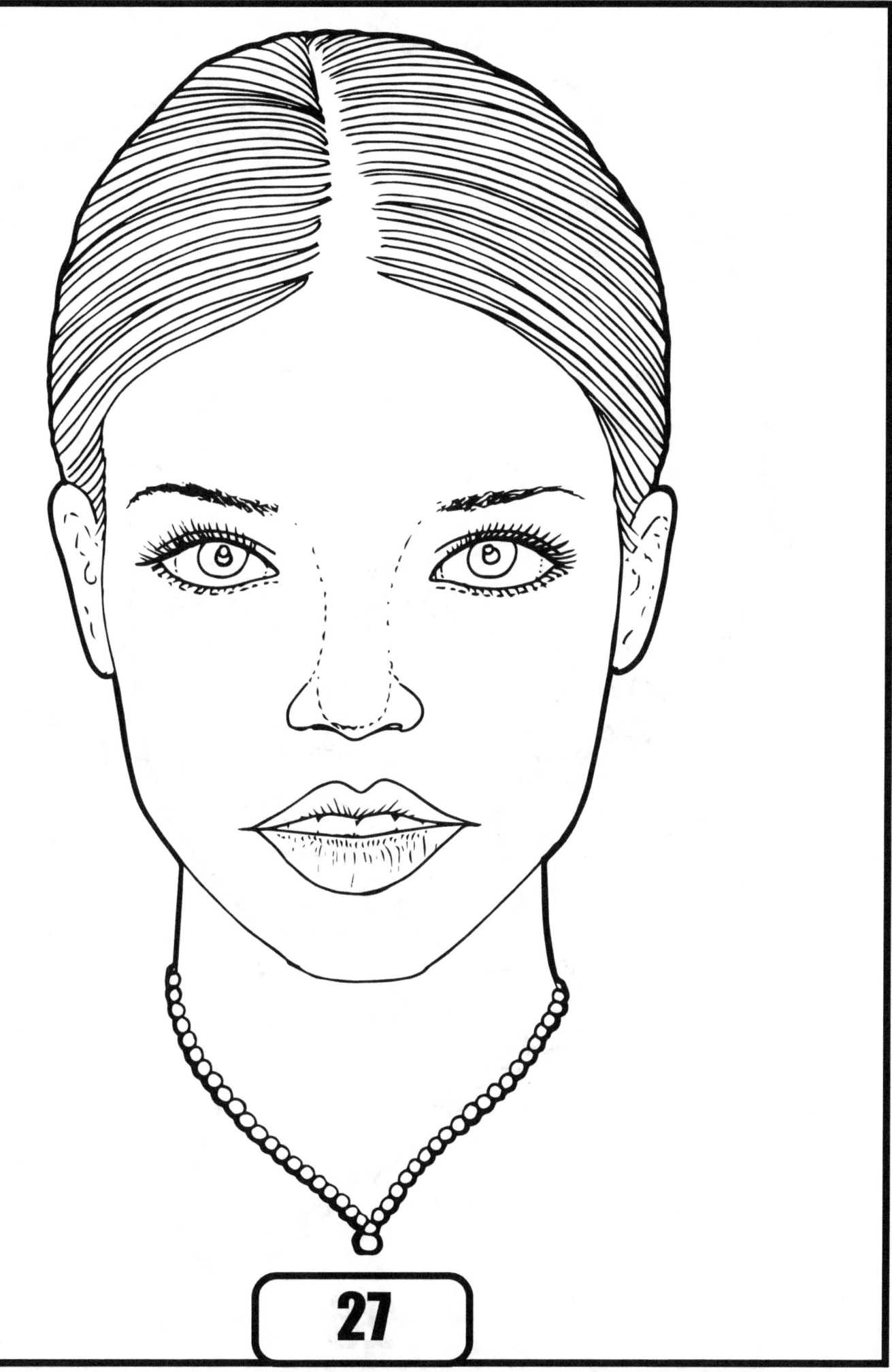

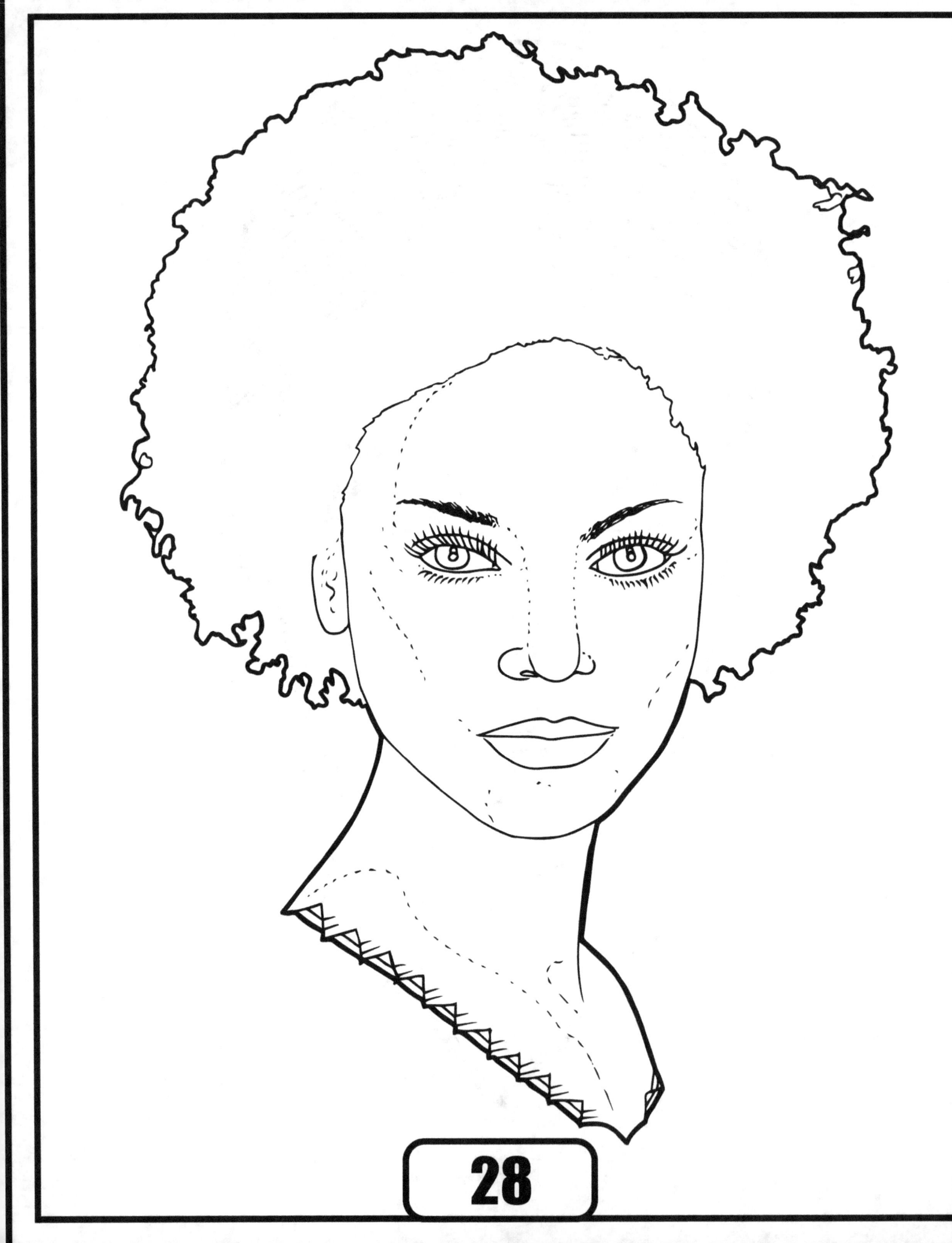

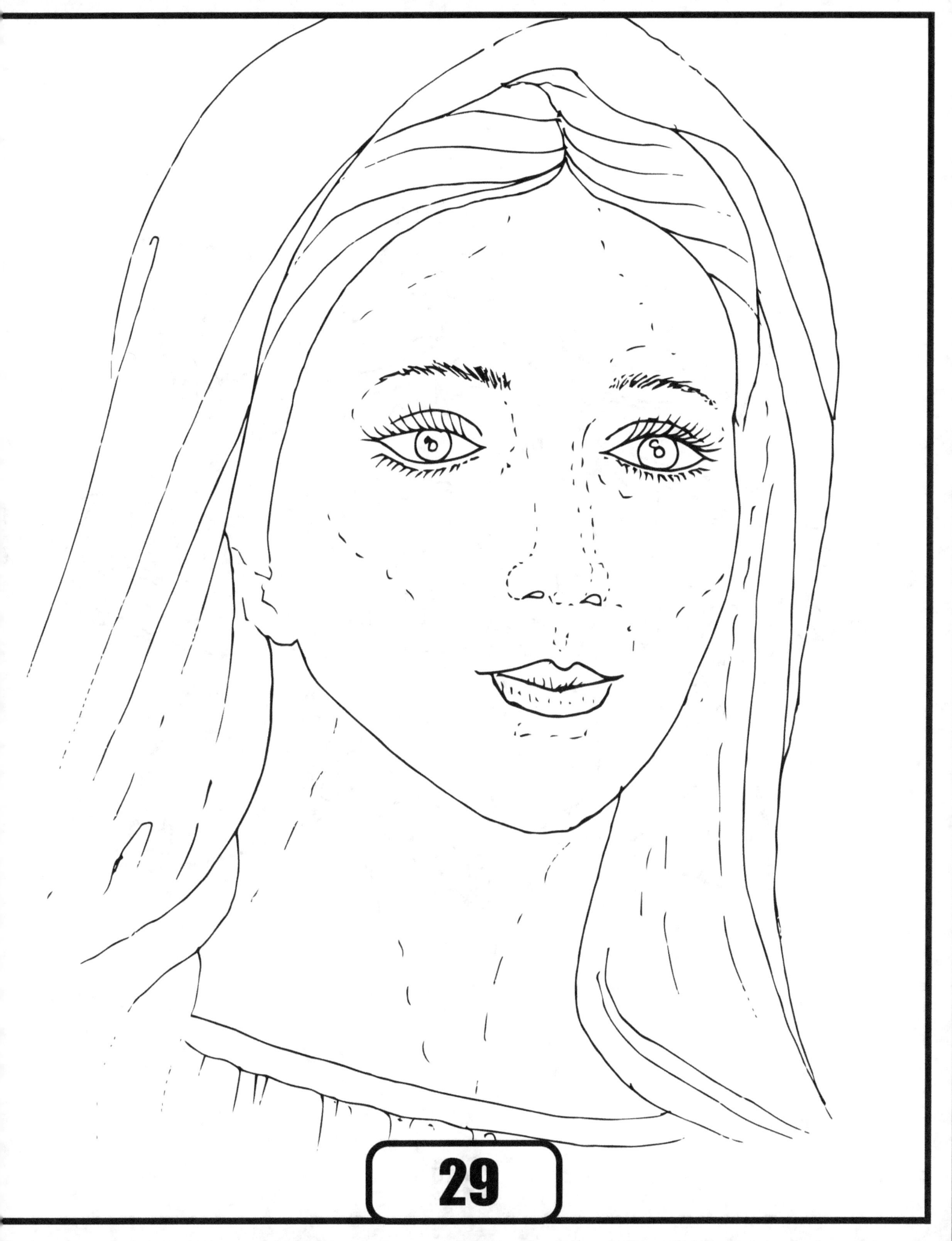

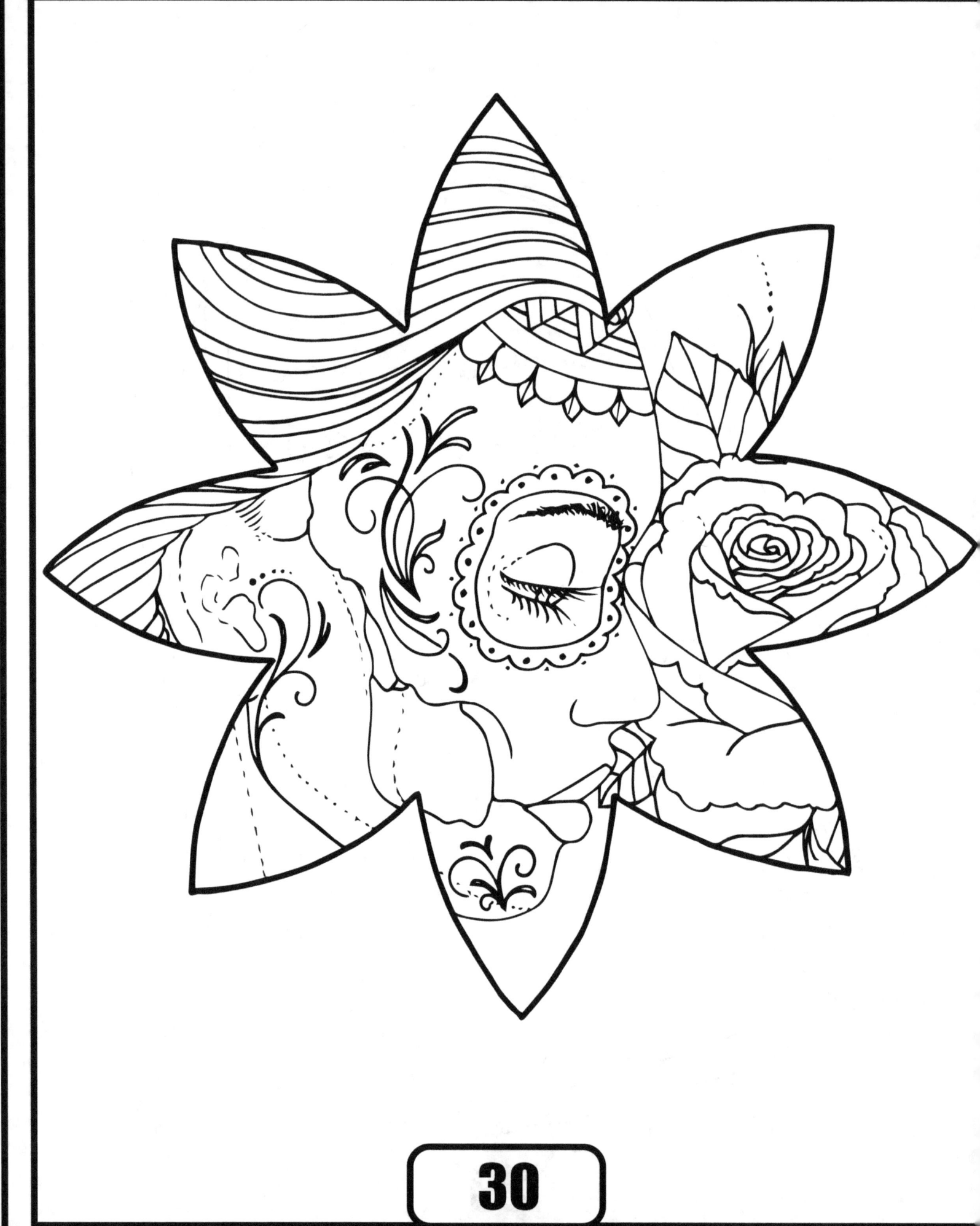

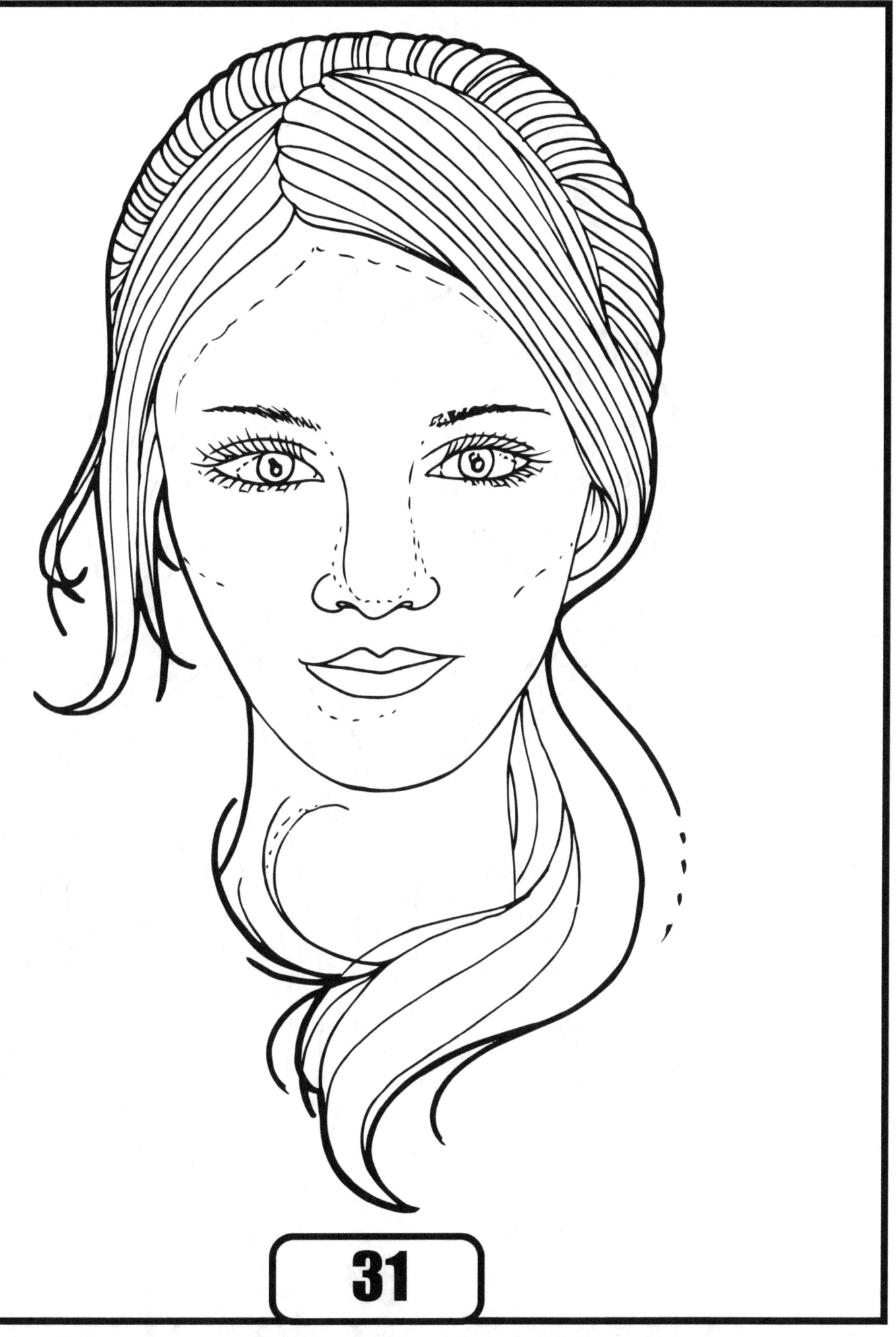

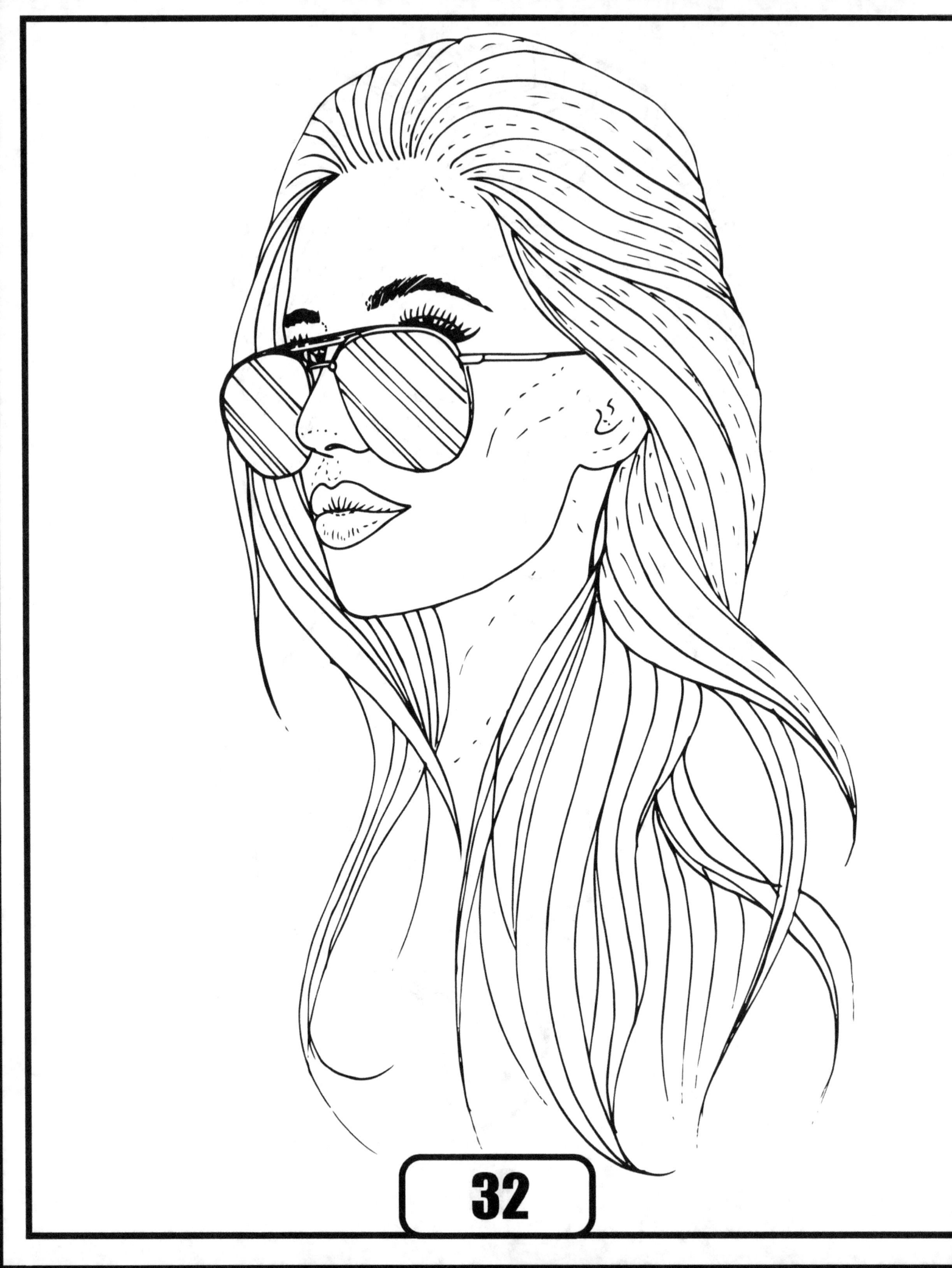

www.ingramcontent.com/pod-product-compliance
Lightning Source LLC
Chambersburg PA
CBHW080856170526
45158CB00009B/2748